THE TEDS

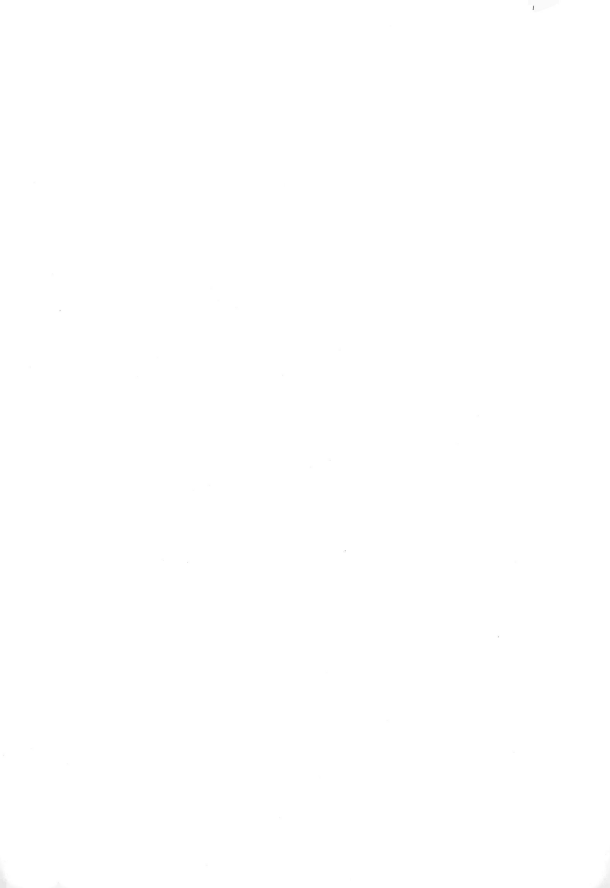

THE TEDS

Chris Steele-Perkins
Richard Smith

dewi lewis publishing

Published in 2002 by
Dewi Lewis Publishing
8 Broomfield Road
Heaton Moor
Stockport SK4 4ND
England

www.dewilewispublishing.com

Originally published in 1979
by Travelling Light/Exit

ISBN: 1-899235-44-2

Artwork production: Dewi Lewis Publishing
Print: EBS, Verona

Reprinted November 2003

*The texts by Richard Smith,
including the comments of
the interviewees, have been
reproduced as they first appeared
in the 1979 edition of the book.*

ACKNOWLEDGEMENTS

"I Fought the Law"
(c&a: Sonny Curtis)
copyright © 1961 Acuff-Rose Publications.
Reprinted by permission of Acuff-Rose Music Limited,
(Chappell & Co Ltd)

"Summertime Blues"
Reproduced by permission Campbell Connelly & Co Ltd.

IPC Magazines Ltd for permission to rewrite some material
which originally appeared in *New Society*.

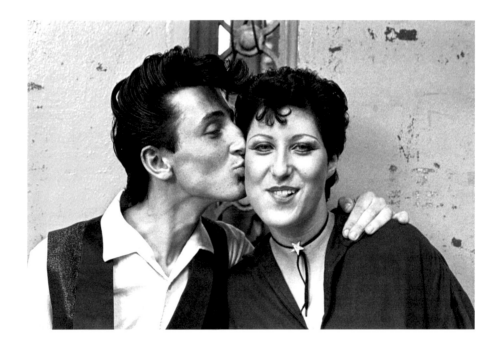

What do I reckon to it, eh? It's fantastic. You can't beat it. The music, Rock 'n' Roll, it's got the beat and that. It's great to dance to. It's not just one thing all the time: it's everything. There's the sax; there's the bass; there's the double-bass; there's all the guitars. Everything, you know, it's fantastic.

The gear: it's smart; it's great stuff; it's much smarter than flared gear. The hair: it's tidy; it's not long and straggly. You walk down the street and you get all the old people — the original people who was there in the Fifties — looking at you and saying, 'Ah, look, there's Teddy Boys.'

You get great screws from people. You get people looking at you as if you were really brilliant like, as if you were really great.

East of Eden

East of Barking, in the Summer of Fifty-four, on a late-night train from Southend to London, someone pulled the communication cord. The train ground to a halt. Light bulbs were smashed. When the train eventually reached Barking, police arrested a gang dressed in Edwardian suits.

In March of that year, a sixteen-year-old youth had been convicted at Dartford Magistrate's Court of robbing a woman 'by putting her in fear'. Said the Chairman of the Magistrates: [1]

'There are a lot of things and so-called pleasures of the world which demand a lot of money. You tried to get hold of money to pay for ridiculous things like Edwardian suits. They are ridiculous in the eyes of ordinary people. They are flashy, cheap and nasty, and stamp the wearer as a particularly undesirable type.'

In April, two gangs, dressed Edwardian-style, met after a dance, at St. Mary Cray, Kent, Railway Station. They were ready for action: bricks and sand-filled socks were used. Fifty-five youths were taken in for questioning.

The Teddy Boy myth was born. The first 'Best Dressed Ted Contest' was held at Canvey Island, Essex, during August Bank Holiday 1954. The winner was a twenty-year-old greengrocer's assistant.

In the fifties, youth throughout the West rebelled. America, the cultural centre, had the outlaw motorcycle gangs, as depicted in the film *The Wild One*. Brando played the mean, moody, and brutal Wild One. The British Censor found this film so subversive that he banned it for nineteen years.

Late in the decade, Australia had the *Bodgies* and their female counterparts, the *Widgies*. Bodgies wore the leather jacket — the aggressive symbol of teenage revolt — and drainpipe trousers; rode motorbikes and stolen cars. The Widgies had their hair piled high in beehives; wore stilleto-heeled shoes and tight, slit, pencil skirts or ski-slacks. Bleached blonde hair and pink lipstick.

The Japanese *Tayozoku* — the 'Sun Cult' — wore drainpipes, sunglasses, and Hawaian shirts. Their hair was chopped in a crew-cut mop: the *Shintaro*. They drank, brawled, screwed and, for a while, attracted the interest of mass media. The British Teddy Boy reflected this trend.

In London, after the War, a style developed in homosexual circles, half-collars of velvet on long Edwardian jackets. It was soon adopted by young upper-class Guards Officers, a last nostalgic wince for the era of Edward VII, 'Teddy', the grandeur that was gone for ever.

After considerable Press, the style moved down market and out into the working-class suburbs. It lost its twee associations and became the high-fashion of a new breed. It took on more menacing connotations and the Guards Officers dropped it fast. By the beginning of 1954, it was purely working class.

This style developed. Now widely called 'Ted' or 'Teddy Boy', it owed less allegiance to Edward VII: more to the western gunfighter. The jacket, the drape, showed clear similarities to the frock-coat of the saloon shoot-out. At first Teds adopted the narrow tie but soon the gambler's bootstring became the convention.

Urban cowboys came to prominence in the Ted culture. The bootstring was held together with a medallion: death's heads, cross-bones skulls, eagles, dollars and

other images of America, miniature boots or holsters, and later, the swastika. Then there was the little cow's head, based on the skulls of long-dead Texas Longhorns which littered the Eastmancolor deserts.

The three-quarter, finger-tip, length of the drape was down to the way you stood: dangling, leaning back slightly, poised to draw: or hunched up on mean street. The drape also owes something to Byron and showbiz, suicidal immortality, a Romantic Gunfighter with a touch of class.

Drainpipes were the second skin; the legs dangled and the strides were long. The Ted swaggered with it all out front, male sexuality overt. The original Ted shoe was the Brothel-Creeper, also known as the Beetle-Crusher or Crepe-Bopper. An American invention, it was like a Martian's landing pad. Thick foam-rubber soles gave grip in the wet and bounce in the dry.

The Teds were in the forefront of the Fifties hairstyle experiments, styles which contrasted sharply with the short-back-and-sides of National Service. There was the crew-cut of the U.S. Marines and Ted versions of the crew-cut: the Spikey-Top and the Silver-Dollar. These were long and short crew-cuts, respectively, but the hair was kept full at the sides and greased back. There was the Mohawk, derived from early T.V. show Canadian Indians: the head was shaved except for a central strip of hair. There was the full, curly head of Tony Curtis. There was the greased-straight-back of the dedicated drinker. At the back, the hair was greased in from the sides to meet the hair coming down. This was the Duck's Arse, the D.A., or, more politely, the Duck Tail. In contrast to the D.A., there was the Square-neck or Boston: the hair was chopped straight in a fringe at the neck.

Towards the end of the decade, the quiff became the dominant mode. The symmetrical quiff was formed by parting the hair across the back of the head. The hair curved forwards from the sides to meet at a point somewhere in front of the forehead. In asymmetrical quiffs, the hair was greased back at one side, parted, swerved round the front, to be swept back at the other side. It could form a helix, spiralling out over the forehead, before continuing its path, if desired.

Whiskers grew at the sides of the face: Sideboards, or Sideburns after American General Burnside. An unshaven top lip, a barely discernible moustache, was acceptable. A beard was not: it would detract from the severe lines of the Ted look.

The hat was a striped Ratter, or Cheesecutter cap. Spectacles, when worn, were of the horn-rimmed TV screen variety.

Teds were Britain's first mass-market existentialists. Anarchists and fast-livers, they acted out the desperado myth. Their crime was the end in itself. Their outlaw image was re-inforced by the tattoo, the Mark of Cain.

They became the focus of male fashion, albeit a disreputable one. Middle-class kids were unfashionable: their parents refused to let them 'ape' the Teds.

In Britain, juvenile delinquency was on the increase throughout the decade. In 1952, a seventeen-year-old and his fourteen-year-old brother appeared for sentencing before Lord Chief Justice Goddard. They had been convicted of robbing another youth, in Epping Forest, using an airgun. Goddard said:[2]

'Nowadays, the cane is never used in school. It would have done them good if they had had a good "larruping". What they want is to have somebody who would give them a thundering good beating and then, perhaps, they would not do it again.

'What can I do with these young blackguards?'

A month later, Dr. Garbett,[3] Archbishop of York, declared himself 'not against birching in principle.' He put the blame for increased lawlessness on films, comics, two World Wars, the break up of the family, and lack of parental discipline.

Concern with comics persisted and in 1955 legislation was introduced to ban the import of the American Horror variety.

In 1953, Tory, Sir Edward Cadogan [4] wrote to The Times:

'...The devastating increase in England of juvenile crime... This disquieting phenomenon has synchronised with a comprehensive rejection of Christian ethics and dogma.'

Echoing the same theme, the Rev. Graham R. Sansbury [5] of Skegness wrote:

'We have always assumed that every civilisation from ancient Sparta to modern Hinduism passed on to the younger generation whatever is believed to be true; we can no longer make this assumption of the Western World.'

In 1953, questions were asked in the House of Commons about the activties of juvenile gangs in the Clapham Common area. Before the year was through, a youth was stabbed to death there.

Dream Dream Dream Dream Dream

In 1950, the Cold War was blowing across the Iron Curtain. Britain still had rationing; this was the era of the spiv in the modified demob suit who looked like Al Capone.

The economy soon gathered pace and the wartime styles faded. Ford took over Briggs Motor Bodies: the Jowett Javelin disappeared and a long history of industrial disputes began. Ford introduced the American style Zodiac, Zephyr, and Consul models, lower, sleaker, fins and curves. Vauxhall (General Motors) countered with the Detroit designed Velox, Victor, and Cresta.

With the Coronation of Queen Elizabeth II, the TV boom began.

Although by later standards the mid-Fifties was not the highest point of British affluence, people were much better off than before. There was the prospect of full employment. The wealthy worker became the symbol of economic progress. There was the salesman with his Ford Consul. The council-house Jaguar replaced the coal in the bath.

The War Children had come of age. The Fifties teenagers lived at a time of increasing wealth. There was a boom in profits, wages, and consumer credit which did not abate until the deflationary measures of Selwyn Lloyd when the decade was through.

Juvenile delinquents at least faced an afffluent adulthood. There was a cause for optimism; rising expectations could be fulfilled.

Until the expansion of mass purchasing power, fashion had been the province of the wealthy: the rest had had to improvise. Now there were new domestic markets to exploit and new methods of marketing.

Girls in Britain adopted the Bobby Soxer style of immediate pre-War America, the girls who screamed at Sinatra. American influences were strong.

Middle-class youth took a renewed interest in jazz and jiving was introduced as a popular dance style. Popular music was, however, predominantly the Swing style of the War years. The American Ballads made some inroads into the British market. The male vocalist was emerging as a seminal figure.

In 1954, mass pop star worship began in earnest. 'Fanomania', the popular press called it. David Whitfield was frequently photographed with his two-tone Buick. In America, explained David from Hull, it was just an ordinary car.

The British big-band singers, Whitfield, Denis Lotis, and Dickie Valentine, who attracted substantial female followings, were essentially nice guy figures. The moody, sensual, rebel rockstar would soon arrive.

Rock 'n' Roll came to Britain in 1954 with Bill Haley's *Shake Rattle and Roll* and Johnnie 'Cry Guy' Ray's *Such A Night*. The Teds, who pre-dated it in Britain, adopted it as their music.

Lamé in Anger

1956, a watershed year, was The Year of The Ted. March saw the only appearance of the mysterious Black Dufflecoat Gang of South London. Twenty-three youths, aged from fifteen to nineteen, entered Orpington Civic Hall late one night, towards the end of a dance.

Trouble was expected from the moment they walked in: they wore Ted clothes but, instead of the drape, black duffle coats, a style usually associated with beatniks, and sunglasses. Straggling across the dancefloor and jostling people, they dragged girls away from their dancing partners. When the Master of Ceremonies called for order, they knocked his hat off. As the police attempted to round them up outside, one of them shouted, 'C'mon, we'll go back in and cut 'em to pieces.' A stilleto and a carving knife were later found.

Ted violence was still restricted to isolated incidents and was on the wane. No longer a minority cult, their style had gained wide acceptance. Then the Bill Haley film *Rock Around The Clock* arrived. The Teds, ready, willing, and able took the stage again.

At this time, September 1956, Bill Haley had five records in the top twenty. *Rock Around The Clock* was shown at three hundred cinemas and then the riots exploded.

At the Gaumont, Lewisham, a Ted mounted the stage in front of the screen, waving his arm in the air and shouting:

ROCK! ROCK! ROCK!

Seats were kicked and cut and other Teds started jiving in the aisles. Great theatre and certainly better audience participation than the 3-D movies which were popular at the time.

At the Gaiety, Manchester, the balcony showered lighted cigarettes on the stalls. In Bootle, police with truncheons escorted a thousand jivers through the streets. At the Elephant and Castle Trocadero, seats were slashed. When the police attempted to disperse a throng of jiving, singing teenagers, bottles and fireworks were thrown; four shop windows were smashed. Two police were injured and nine Teds arrested.

A hundred and twenty teenagers were thrown out of Stratford, East London, Gaumont. A police spokesman said that they were 'ranting and raving' as they danced on the flower gardens in front of the cinema.

The film was banned in Birmingham, Blackpool, and Belfast but not in Oldham or Cheltenham Spa. Rioting followed it to Oslo, Copenhagen, and Buenos Aires. It was banned in Iran and Indonesia.

Reaction was inevitable. Sir Malcolm Sargent, idol of the *Proms*,[6] claimed that Rock 'n' Roll was:

'Nothing more than primitive Tom-Tom thumping. The amazing thing about Rock 'n' Roll is that youngsters who go into such ecstacies sincerely believe that there is something new or wonderful about it. Rock 'n' Roll has been played in the jungle for centuries. Frankly, I think if Rock 'n' Roll is capable of inciting youngsters to riot and fight then it is quite obviously bad.'

Sir Malcolm then left to celebrate the seventy-fifth anniversary of Johannesburg. The Bishop of Woolwich flashed his own blunt razor: [7]

'The hypnotic rhythm and wild gestures have a maddening effect on a rhythm-loving age group and the result of its impact is a relaxing of all self-control.'

Youth had its say too, in the *Daily Mirror*'s Teenage Parliament: 'Teddy Boys' M.P.s you might call them.' [8]

Elvis Presley became very big in Britain in 1956 and established the masculine stereotype for a generation.

Most of the young British pop musicians at this time were playing skiffle, a jazz based style, but then Larry Parnes launched Tommy Steele, the first great British Rock 'n' Roll star, in a blaze of publicity. *The Daily Mirror*:[9]

'NOW BRITAIN GETS A PRESLEY. But Rock 'n' Roll Tommy says, "I hate him.

I was singing like this before Presley; Bill Haley's my man".

'GO TO IT, TOMMY!'

Former journalist Parnes continued with the Tommy Steele formula for a number of years: Vince *Eager*, Duffy *Power*, Marty *Wilde*, Billy *Fury*, Tommy *Quickly*, and Adam *Faith*. In the early Sixties, at great expense, he launched Canadian, Daryl Quist. But Quist, while gesturing to female fans, fell from the stage into the orchestra pit and oblivion at De Montfort Hall, Leicester, on his first British tour.

In 1956, there was a vice scandal running in the newspapers and the West End of London. I was six years old then, living in Nottingham. Behind some garages, another kid asked me about sex. I told him it was something Teddy Boys did to prostitutes.

Lyons Cakes introduced the first industrial computer at their Cadby Hall bakery. 'Skeleton found unconscious on Skegness Beach,' declared *Billy's Weekly Liar*.

She Wore Leopardskin and her Tits were Big

Princess Margaret didn't get into Rock 'n' Roll until 1957. She went to see Jayne Mansfield in *The Girl Can't Help It*, with a 'gay young party of ten' including Billy Wallace, Antonia Fraser and husband Hugh. She tapped her stockinged feet on the brass rail of the Royal Circle, to the rhythm of Little Richard, and made the front page of the Daily Express.

Bill Haley, hair in a kiss-curl, hit London on 5 February 1957, when he steamed into Waterloo Station on the 'Daily Mirror Bill Haley Special' to the screams of three thousand fainting fans.

Seat slashing ceased to be news in 1957. There was some vestigal cutting and fighting at Hendon Gaumont during a showing of *Don't Knock The Rock*, a film in defence of Rock 'n' Roll. But the pace of the Teds was cooling down.

They attained notoriety again in 1958 as the leading exponents of Race Rioting, beating up blacks. The trouble started in Notting Hill, West London. Then Teds in Nottingham, 120 miles to the North, took up the cudgel.

Nottingham's Chief Constable, Captain Popkess explained:

'This was not a racial riot. The coloured people behaved in a most exemplary way, by keeping out of the way. Indeed, they were an example to some of our rougher elements. The people primarily concerned were irresponsible Teddy Boys and persons who had had a lot to drink.'

At the end of the Fifties, the Teds wound down; they had set a scorching pace. They had fought in fairgrounds and Locarnos, alleys and arcades. They had created outrage: outrage had created Teds. They had cut cinema seats. Their style was exotic, alien, menacing: Brylcreem elephant trunks, drapes, drainpipe trousers, luminous socks, beetle-crushers.

Out on the streets, you could still find the fights. Down at the municipal baths, there was the penny-in-the-slot Brylcreem dispenser. A quick white greasy squirt after a tone-up swim, the Ted could style his quiff, flicking and stroking with his plastic comb.

Then out back with the gang up the bus-shelter, someone might have got his head kicked in by baseball boots, boppers, or cowboy boots with spurs.

The Teds had found their identities in the gangs. They had moved from the back-streets to the housing estates and headlines. And they did it to the back-beat of Rock 'n' Roll.

Then they settled down; did their National Service; hung up their drapes; got married; did their jobs. Around 1959, they traded in their beetle-crushers for sharp Italian-style winkle-pickers.

They became institutionalised in talent contests, miming contests, and best-dressed contests. Theirs was still the top style for a few years. Then it was the bum-freezer suit, then the Mods.

Of course, many of the Teds kept going, hanging around in the back rooms of boozers, and congregating every time an ageing American rock star toured.

Younger kids donned the Ted dress too. Some changed to leather jackets and became the Rockers who fought the Mods in the seaside battles of the Sixties.

Time passed; age took its toll.

Kenny

Stan the Man

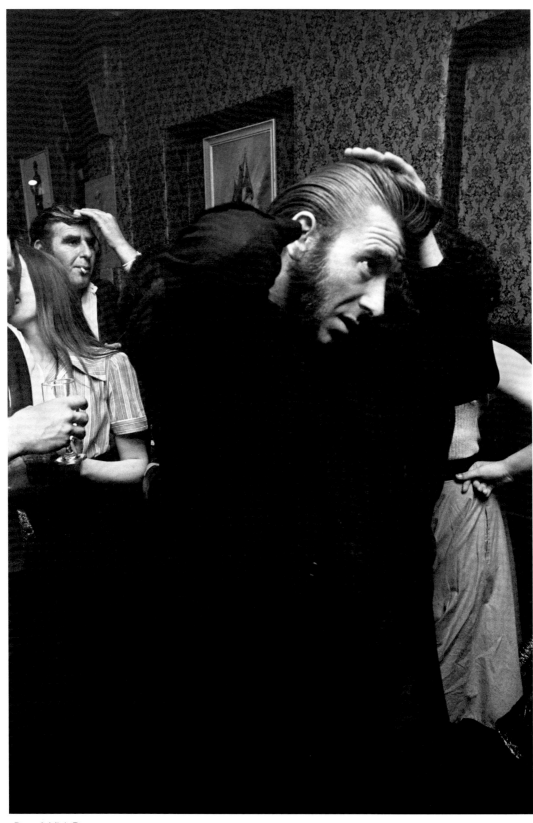

Dave & Mick Ransome

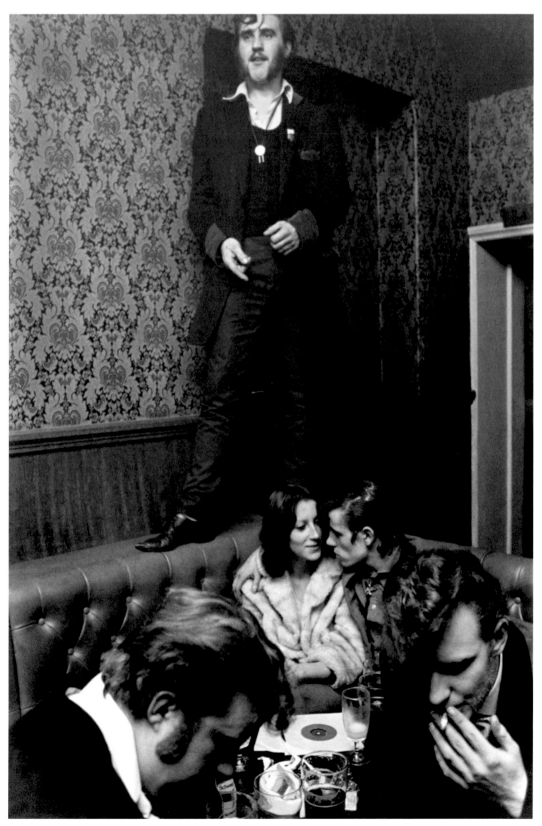

Barry Ransome

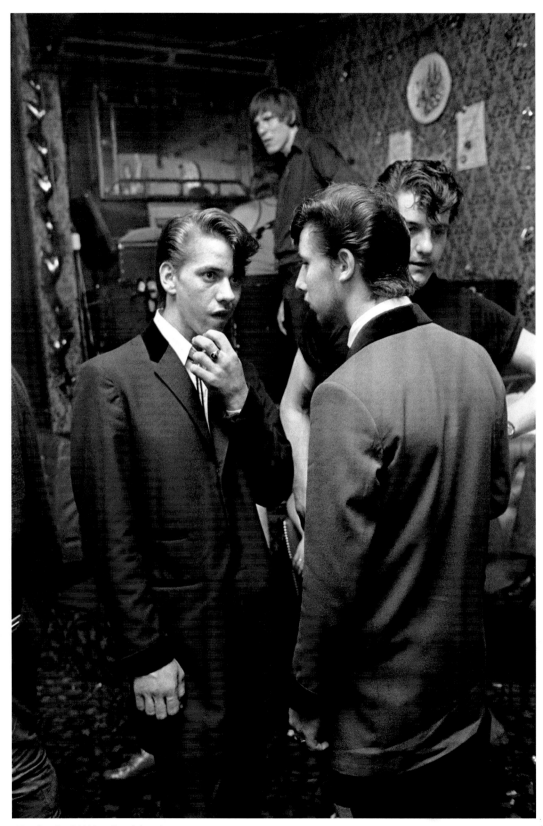

The Castle, Old Kent Road, London

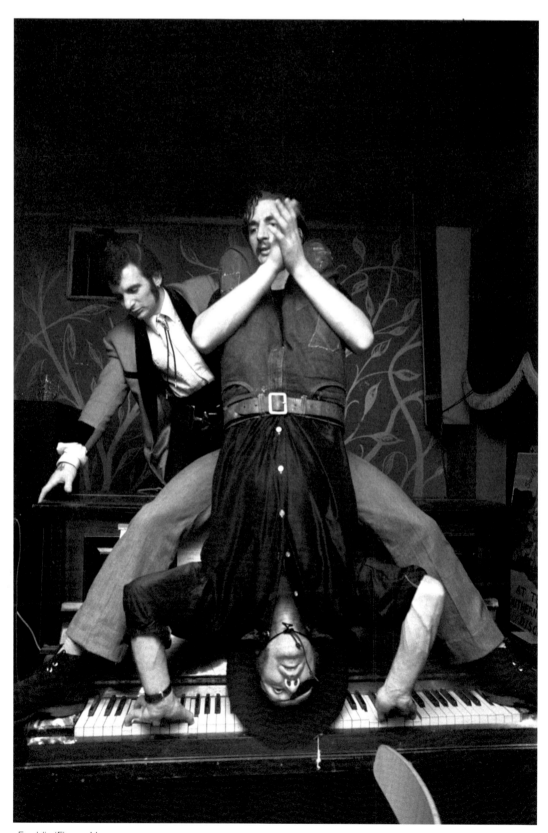

Freddie 'Fingers' Lee

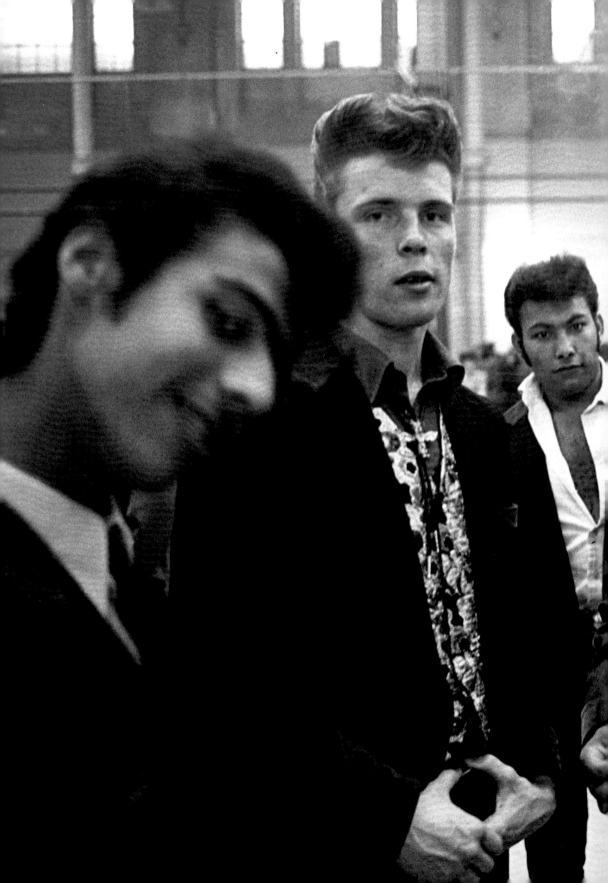

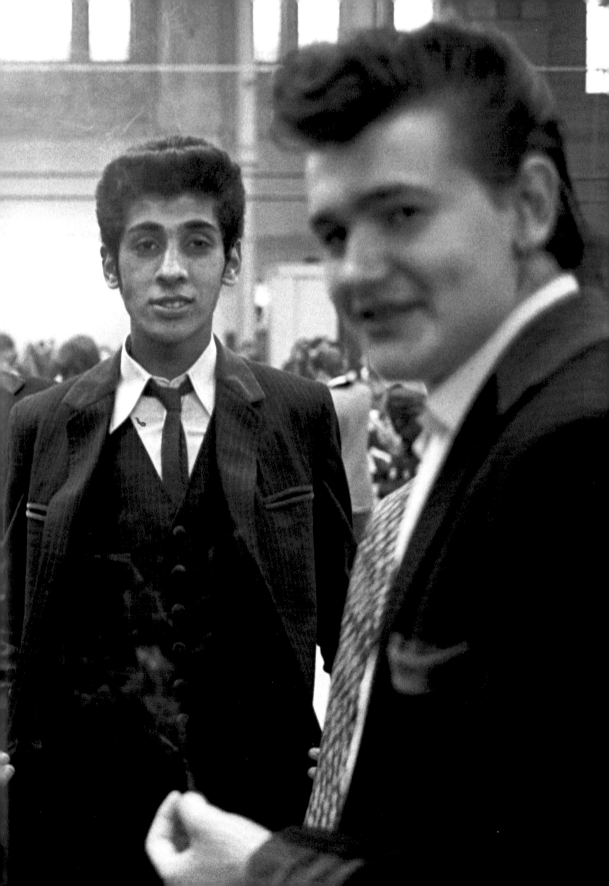

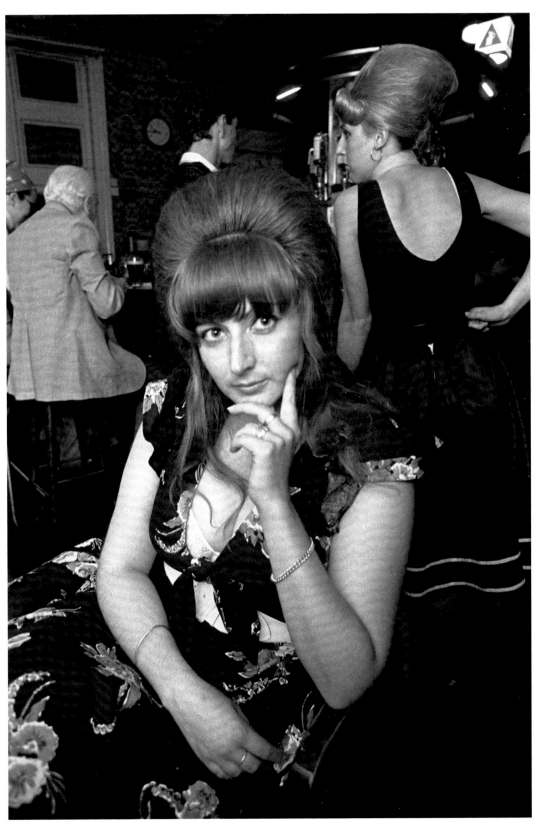

Cheryl

A Little Less Conversation — A Bit More Action

In 1967, at the height of Flower Power— mainly a student phenomenon—Bill Haley's *Shake, Rattle and Roll* crept into the charts again. Pop's instant nature is its nostalgia; the ephemeral had attained a permanence. The Fifties was the beginning of the period to return to.

The Teds had lingered on. From 1967 onwards, they were again on the increase. The style had changed: the drapes were brighter; the drainpipes tighter; hair lacquer started to replace grease. The meaning had changed too. Teds were no longer the hard-core nasties; they went unnoticed. They were merely nostalgic adherents to Rock 'n' Roll.

Young kids continued to join the Teds. The thirty-year-old old-timers, the Originals, formed the leadership. Veterans of the Fifties, they had been there. Respect for age, absent at the start, was becoming a corner-stone of the Teds.

The Originals were clearly committed to the life-style. The second generation developed a strong identity. Then, in the mid-Seventies, a third generation adopted the Ted style, fashionable Seventies teenagers, spurred on by backtracking radio, TV, and the cinema. The young Seventies Teds were the plastics. Some were the children of Originals: others were out for a good time. Being a Plastic was not only a question of age, however, but also of commitment. Plastics were unlikely to go through the initiation of tattooing. They were subject to abuse and banter from the older boys. They are the traitors of the song *Rock 'n' Roll Traitor* by revival band Cadillac.

The Mods had the Toytowners: fake, second-string Mods, lacking in cool, the criterion of Mod culture. Hippies had the Weekend Raver, a bank clerk in a Kaftan. Skinheads had the Suedeheads or Suedos. And the Teds had their Plastics.

Ted racialism persists, although it is seldom extended to Black Teds. Black singers gained a wider acceptance with Ted audiences in the Seventies. This may to some extent be due to the fact that black singers were not subject to the white cover versions of their work, as they were in the Fifties.

In the late Sixties, the first of the new-wave Teddy Boy bands, Shakin' Stevens and The Sunsets appeared. Stevens, 10 years later, went on to greater things playing Elvis Presley in the musical *Elvis*. Stevens developed a following amongst the Teds and his nostalgic appeal went down well with college audiences. About the same time, The Wild Angels revived Fifties Rock 'n' Roll and took to wearing drapes.

Screaming Lord Sutch, a great showbiz Rock 'n' Roller, attracted publicity throughout the Sixties and regularly gave his own version of the Fifties sound. But Sutch is all things to all men, a showman in the freak-show tradition and, as such, he is timeless.

There were the small town Teddy Boy bands who had always played Rock 'n' Roll, like Mansfield-based Ritchie Satan and The Devils. I saw them at Hucknall Miners' Welfare. They were great: pure Ted, totally lacking the musical sophistication and self-consciousness of the revival acts. For them, there was nothing to revive; they were not subject to changes in fashion.

Plastics derived a great deal from two acts most derided by mainstream Teds: Alvin Stardust and Showaddywaddy. Alvin, also from Mansfield, had been a rock star in the early Sixties, as Shane Fenton. Bearing an uncanny resemblance to Hawaii Five-O TV star, Jack Lord, he became an overnight sensation in 1973 with an overdone, camp re-iteration. His hair dyed black (or was it bleached before?) and quiffed, a black leather catsuit, a gloved fist full of rings, he hit the right chord, a coy boy.

Showaddywaddy arrived appropriately via the television talent contest New Faces. Fast, all action, they resurrected Eddie Cochran and Buddy Holly. Dressed in bright drapes and drains, they were the first transparently Plastic band. Immediately, there was a host of Showaddywaddy copies.

In the mid-Seventies, pop seemed to have lost a clear sense of direction, except back: the emphasis was on nostalgia. Then came Punk. Punk, itself a revamping of various styles, came out of the art schools and into the concrete playgrounds. It was banned like Rock 'n' Roll so many years before. 'Everything is so fucking boring, Man. Everything is so fucking boring,' said the late Sid Vicious of the Sex Pistols. He wore a torn, graffitied T-shirt with Afrika Corps goggles strung around his neck. 'We're not intellectuals.' The music, discordant, loud, throbbing, fast to the threshold of oblivion. Jibber jabber up and down like zonked out calisthenic Draculas, going ape-shit.

If suits were worn they were the old bum-freezer style, preferably of synthetic material. Drainpipes: ill-fitting, nylon plastic paint-smeared razor-slashed. Scruffy scuffed winkle-pickers. Zips, torn shirts and cheap plastic sunglasses, swastika armbands, a style at the end of its tether, cocaine anarchy. The women looked like Anita Pallenberg as the Black Queen in *Barbarella*. The invaders had already arrived. Fetishistic, masochistic, violent and violated, safety pins dangled from the nose, bog chains for the ear, nose, and throat.

The Punks looked messed up; just right; the fabric was torn. They took their name from the hobos' young boys of Depression America. Both Punks and Teds call non-members of their fraternities 'Smoovies'. I overheard a conversation at the Roxy, a Punk Club in London's Covent Garden. 'Bit of bovver last night, four smoovies. Smoovie put his hand up a Punk bird's cunt.' Teds, resenting the publicity that Punks were receiving, hung around Hammersmith Underground Station waiting for them to come from a nearby Punk pub. Then they did them over. 'Teds are number one; always will be.' The trouble spread to the Saturday route of Chelsea's Kings Road, where the Teds were greatly outnumbered. The Punk-Ted battles never really caught on and were insignificant compared with the Mod-Rocker war. By the time Elvis died, peaceful co-existence was established.

Some Teds, striving for authenticity, returned to the roots: not to Rock 'n' Roll or the blues but to a Deep-South whitened blues: Rockabilly, Country singers deriving a style from black spirituals. The main adepts of Rockabilly, the Rockabilly Rebels, embrace the politics of the National Front and of racial segregation. They wear the Confederate flag. Many Teds cannot stand Rockabilly and will boo whenever it is played.

Elvis started off on Rockabilly. Classics of the genre, Charlie Feather's *Defrost Your Heart*, a song which would not have made sense before the advent of the mass-produced fridge, and Carl Perkins' *Blue Suede Shoes*. Hank Mizell's Rockabilly song *Jungle Rock* was a hit in Britain sixteen years after he had recorded it. It took him from the Tennessee dole queue to stardom. The record was initially revived through the Teddy Boy renaissance.

For Pop, the Fifties struck a chord more resonantly than any other period. It was the beginning; the lost innocence lies there. Fifties nostalgia provided Teds with an affirmation. They are remarkably durable. Unlike other teenage sub-cultures, they have persisted as a coherent movement but, in the process, they have changed with the passing of the years.

Serious Seventies

In December 1976, a jumbo jet carrying Bill Haley and The Comets touched down at London. Bill gave his London concert the following night. Coachloads arrived at the New Victoria Theatre from all over the country. Young Teds, old Teds, middle-aged couples out for the memories, and the curious.

'We want Bill.'

The tuxedoed compère took the stage. He introduced The Comets, one by one. They sprinted on, dressed like Butlin's Redcoats. After a brief instrumental: 'The man you've all been waiting for...'

Bill strolled on casually, looking a little podgier twenty years on, his kiss-curl less prominent. 'I love it in Britain; I love it in England; This has always been a home for me.'

He picked up his guitar and the Teddy Boys roared. They left their seats. Some pressed up against the barrier in front of the orchestra pit.

After the first song, two Teds and a Rocker climbed onto the orchestra pit. A Ted made a rush for the stage but was grabbed by the Be Friendly bouncers. Slowly more Teds climbed over the barrier. Others made runs for the stage. People started jiving in the aisles; some sat on others' shoulders and clapped their hands. More of the audience moved forward, clapping and shouting. The Safety Curtain came down.

A middle-aged Ted marched up: 'Do you want this concert to go on?'

YES!

'Well, fucking behave your fucking selves.'

'Oo, who's a hard man, then?' asked a girl in the front row.

'If you want Rock 'n' Roll here behave yourselves.'

People shouted at each other to sit down. Enter Sunglasses Ron: 'If you don't go back to your seats, the concert's got to stop. So for fuck's sake get out of the pit.'

Some Teds left the pit; the audience abused them. Others remained; one made a gesture with his fingers. 'Wankers.'

'Come up here and say that,' replied Sunglasses.

A Ted who looked very similar to Ron walked forward. A snatch squad of bouncers moved towards him. He removed his horn-rims and shouted at Ron:

'You're just in it for the fucking publicity.'

A rather nervous compère reappeared. He repeated his introductions. Bill walked on, grinning. 'You know I love you all very much indeed, so be good boys.

'Here's one that you'll remember...'

As soon as he started to play *Rock Around The Clock*, people moved forward. A girl rushed for the stage. A Ted thumped a guy with long hair, gesturing for him to get it cut. Bill moved to the back of the stage, behind his band. After three songs, the safety curtain descended again. Bill moved forward and waved. 'Good bye, London, you've been a wonderful audience.'

Some of the audience moved forward to attack the crowd in the orchestra pit. They retreated on to the stage. A Ted wielded a short piece of scaffolding tube; another Ted pointed at him: 'You're dead.'

Beer cans were thrown. As the Teds slugged it out up front, the police entered from the rear. Outside, a Ted sat in the back of a police meat van, his cut face pumping blood. Thus ended the return to London of Bill Haley, the first hero of Rock 'n' Roll. His *Rock Around The Clock* has sold more than twenty million copies.

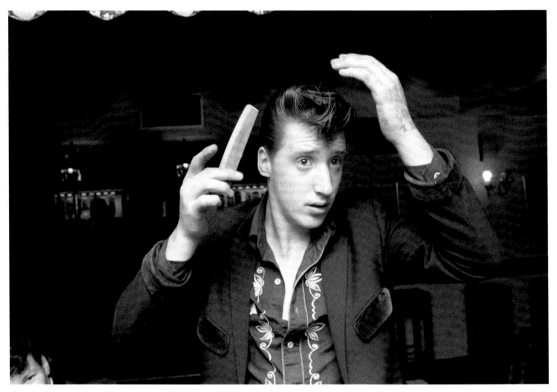

Market Tavern, Bradford

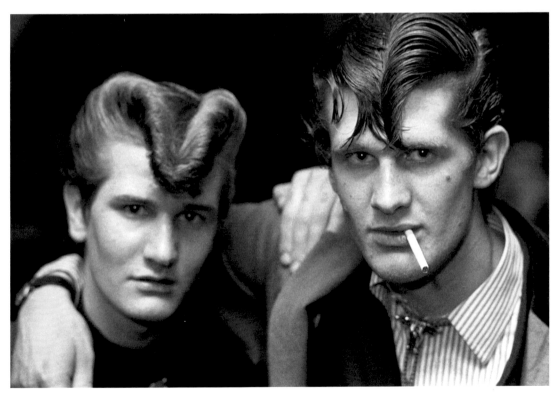

Red Deer, Croydon

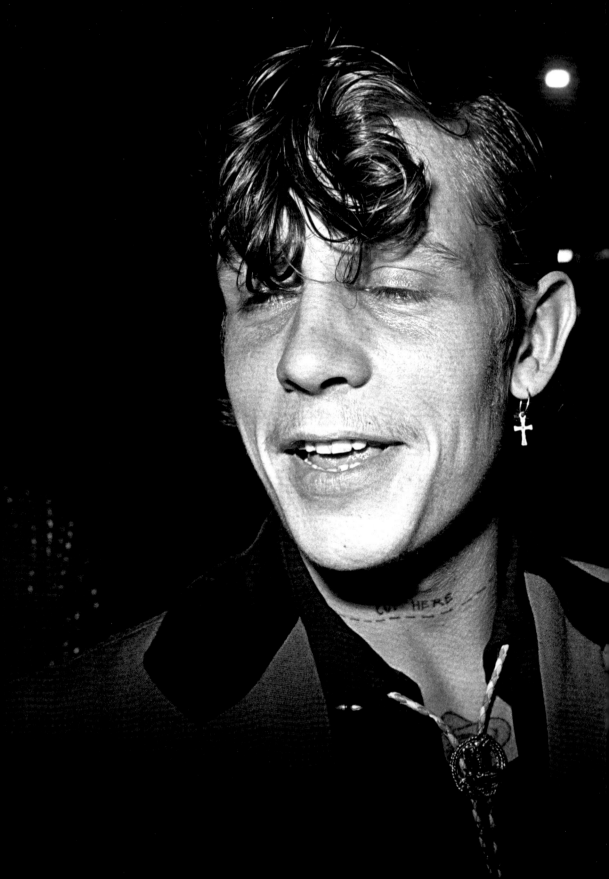

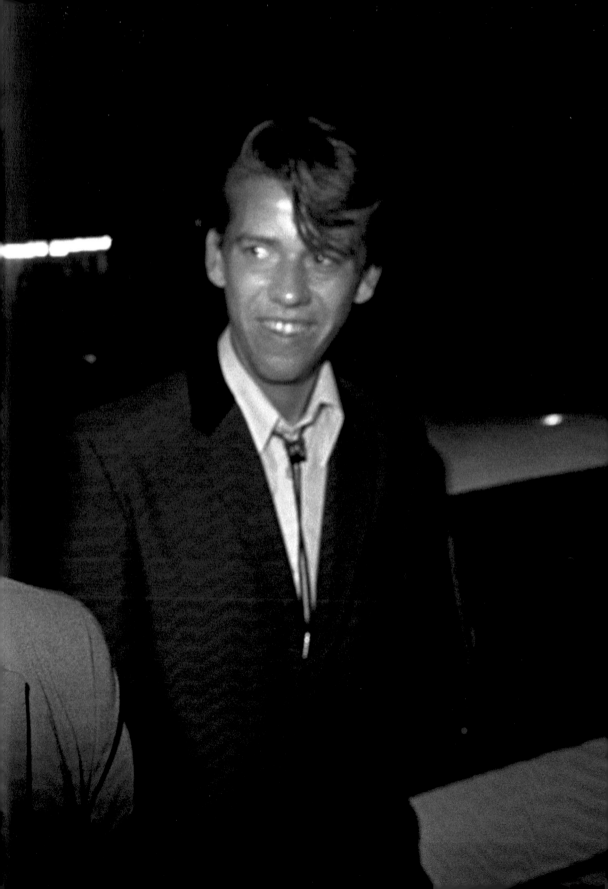

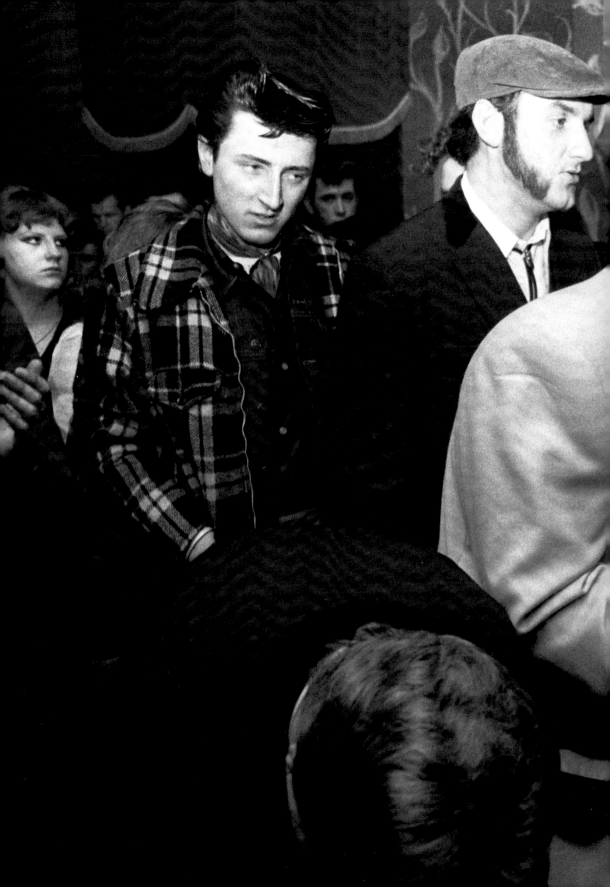

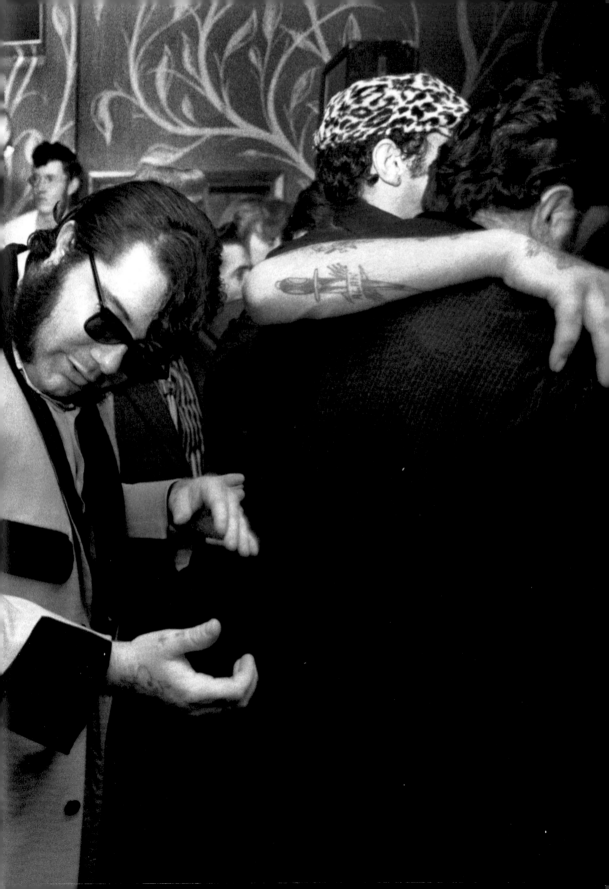

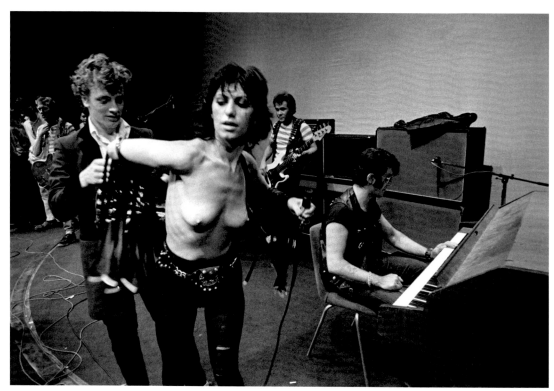

Wild Angels and Phyl Zinon

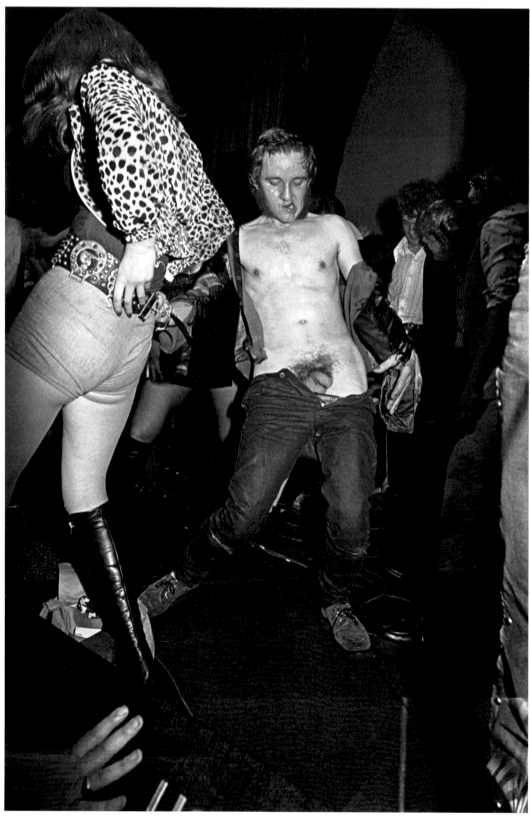

Harold Harris

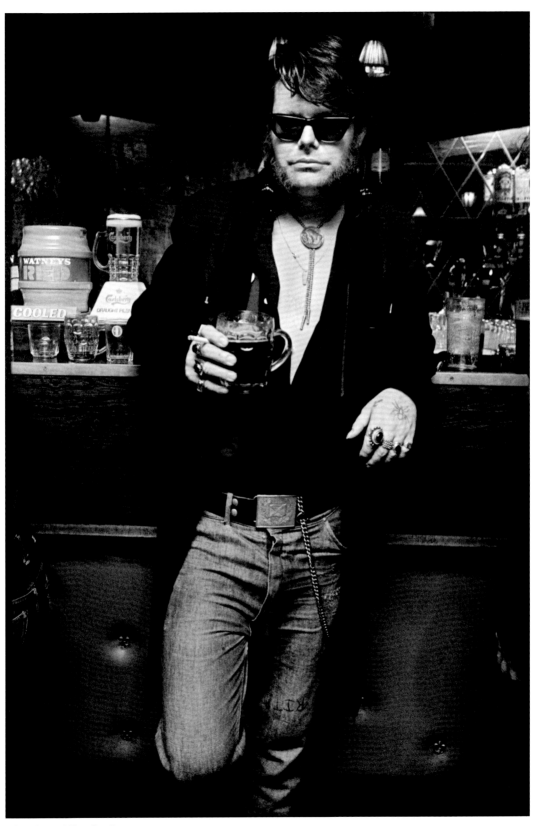

'Sunglasses' Ron Staples

The Return of the Man in Black

Ron Staples came to London from Newport, South Wales. He is a toolsetter and self-acclaimed King of the Teds. They call him 'Sunglasses Ron' but they're not really Sunglasses because he can't see without them.

He stands at the bar of the Lyceum Ballroom; he poses. He wears a black drape jacket and black gold-braided shirt. A brass chain hangs from the brass buckle of his gunfighter belt to his blue jean pocket. His crepe bopper beats the beat.

They hold the Rock 'n' Roll Revival Show at the Lyceum — the World's Most Famous Dancehall — every week. It's Teds' night in The Strand: the bouncers' night off. (But the man in the tuxedo has his eye on the Road Rat motorcycle outlaw in the fawn cowboy hat.)

Through to midnight, jive to three live bands and the resident disco; The Wild Wax Show. A thousand Teds in the garish red Mecca light. Some bop; some jive; some drunk. Box two-tone drapes and Dionysian Brylcreem horns shaking all over.

Jailhouse John works the Wild Wax Show with Rockin' Roy Williams and Wildman Stu Wester. He started off on Rock 'n' Roll and bought a drape out of Burton's.

'You've got to look right. You can sing *Blue Moon 0' Kentucky* just like Presley but if you don't look right... If a band doesn't look right, they're halfway out already. Trouble is now, you're spoilt in London as far as Rock 'n' Roll's concerned.'

The Wild Wax Show projects slides of themselves on to a screen at the back of the stage. Rockin' Roy stands in front of a giant image of himself and mimes to the music. Crepe-boppers bee-bop-a-Lula cross the dancefloor. A young Ted does the 'Bop'. He falls forward, landing on his hands, and does press-ups in time with the music. Then, he flips over on to his back. He leaps up and forward. He runs very fast on the spot, leaning back. His beetle-crushers bounce off the floor. He bops.

A stilleto-heeled girl twirls. Her pleated skirt spins up to form a white disc and reveal her black, seamed stockings and suspender belt. They were jiving. The man picked her up in his arms with all his might. He shook her around, throwing her between his arms. She flew through the air.

MY BABE SHE'S GOT GREAT BLUE EYES AND LONG BLACK HAIR.

Then, he whipped her between his legs and she flew forward.

Wild Angels, a band of Hell's Angels' origins, played the final set. Phyl Zinon, a lady dressed in black leather and black, jumped onstage. She wore a studded belt with a giant brass buckle. Teds crowded up there too.

Phyl performed a strip without tease.

Harold Harris, a hairdryer repairer from Hemel Hempstead, joined Phyl. He removed his shirt, then flashed a limp one.

Wild Angels played out their grand finale — they were barred from the Lyceum after this gig. Harold got dressed again. People filed out into the night.

Later, Phyl wrote: The bodi talks
No-one talks
I wanna get a groop togeva
blend in wiv the boys
lacquered quiffs very phallic

Red hot spunk on a Friday night
Hit them boys
lets have a fight.

After All These Years

The Trocadero Cinema, scene of *Rock Around The Clock* riots, no longer exists. Just down the Old Kent Road from the Elephant and Castle stands The Castle pub. Sunglasses Ron organised the Rock 'n' Roll nights at the pub. He calls it the 'Confederate States of America'. Every year, Ron is elected 'President of The Confederate States of America In Exile'.

On the wall, next to the D.J.'s rostrum, is a life-size cut-out photograph of Ron and a girl. 'She's someone I used to know...'

Ron, likeable rogue, latter day Teddy Boy star, his photograph has appeared in most popular newspapers. Philip Hedley, Director of the Fifties revival musical *Leave Him To Heaven*, used Ron as technical advisor. Ron is the archivist and administrator of the Teds.

Tonight, Ron is with Rita. 'She's carrying my baby, the next Elvis Presley.'

Teds queue to use the mirror outside the gents' bog. The D.J., Stu Coleman of the Timespan Disco, announces Buddy Holly photos. Girls crowd round the rostrum.

Tony Knox and Kenny Wilson both went to school locally. They have found jobs stripping labels off cans in a warehouse. They have ordered drapes from Bob Martin's on Walworth Road.

Their dads were Teds. Tony and Kenny were walking by the pub one night and an old Ted told them to come in. Now they come every week.

Sheila works at the racing stables in Epsom. She goes to Rock 'n' Roll every night. 'I think the Teds are lovely, beautiful. I like the clothes they wear; the way they act; and I like the music they like. Most of the time, I follow a band round — The Impalas.'

The D.J. calls out the winning raffle ticket number. A thirty year old Ted, in a scarlet three-piece drapesuit with black collar and cuffs, sprints up.

'Yes, it's our regular winner. How does he do it?'

He collects his prize: Memphis Rock 'n' Roll, Volume 1. It's Pete Barnes, a fitter from Forest Gate, and brother of Chester the Table-Tennis Champ. How does he do it?

'Easy, I win a prize nearly every week. I don't piss about: I buy a quid's worth — stands to reason.

'I've been a Ted since I left school sixteen years ago. In the old days, these youngsters wouldn't have been allowed in: we'd have kicked 'em out.

'I get my drapes made at Manny Nichols of Romford. (He shows the label on the inside.) Always the same style: flash, too flash really. They call us the F-E-C: the Fire Engine Club. The real old-timers, dark drapes and socks, used to go down the Black Raven. That's gone downhill now.'

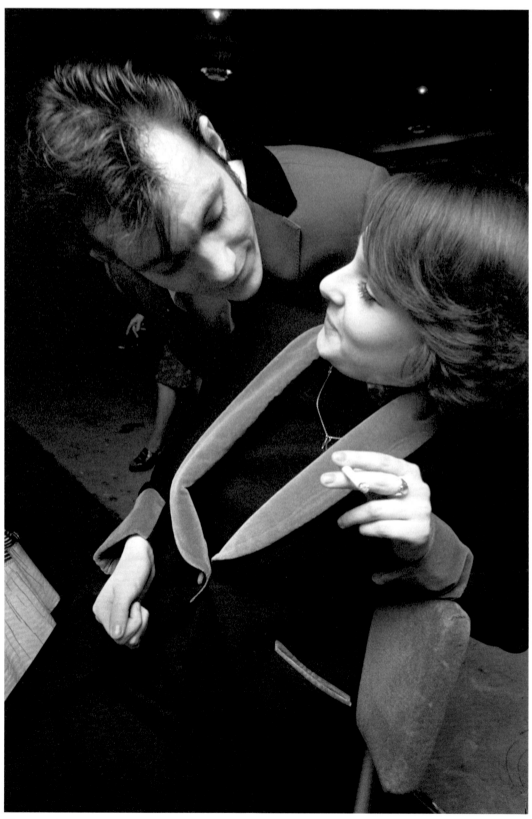

Portsmouth

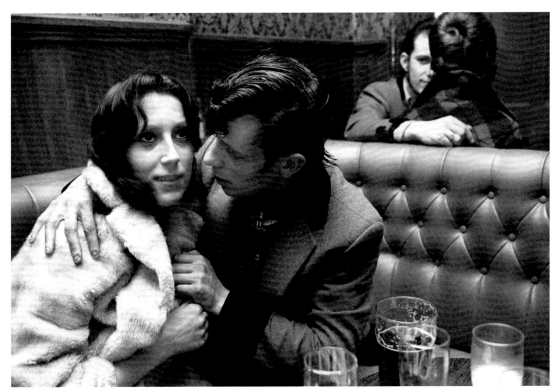

The Castle, Old Kent Road, London

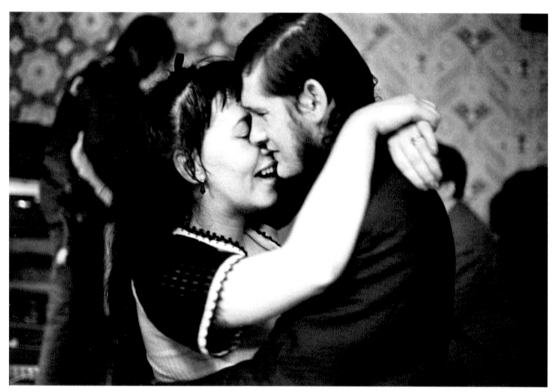

Newcastle

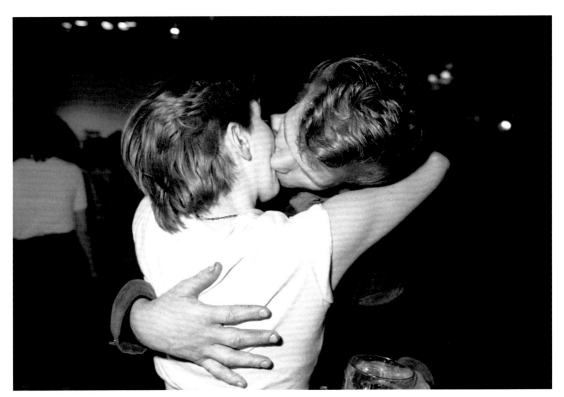

Lyceum Ballroom, London

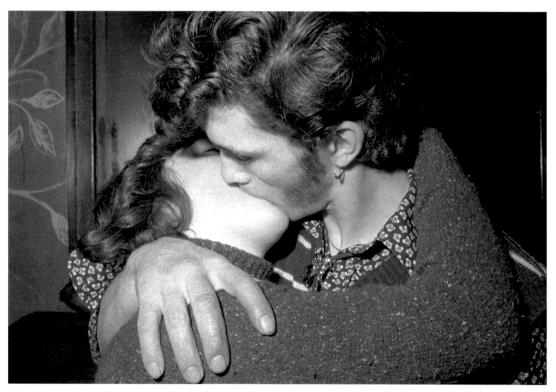

The Adam and Eve, Hackney, London

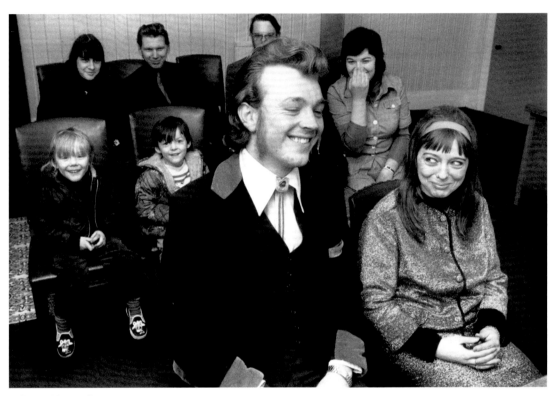

Mike and Lynne Goose

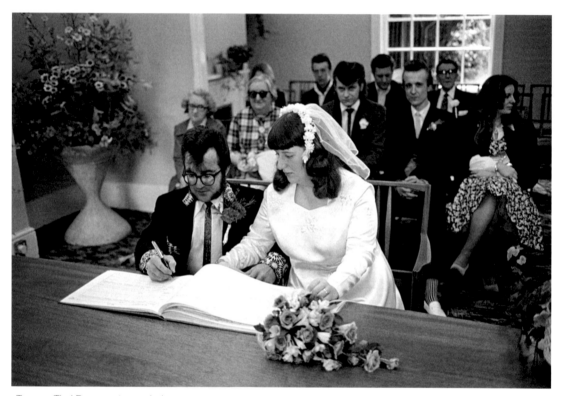

Tongue-Tied Danny gets married

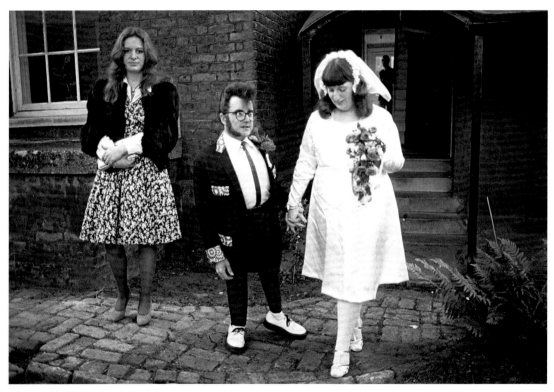

Tongue-Tied Danny gets married

Flashback

Fifties Flash ran the Bobby Sox Club at the White Horse, Willesden, West London. He wore a silver lamé drape with a black velvet shawl collar. A Confederate Flag hung from his turntables. Memphis Paul stopped by briefly in a '58 Cadillac Fleetwood, which he had bought off Local-Ted-made-good, Screaming Lord Sutch. Paul, balding, had a lacquered quiff which looked like beetles' mandibles. He met a girl on the dancefloor and left. Tony and Ann Fisher had just got married. Ann brought their album of wedding photographs along. 'Come down Scotland Yard any-time,' quipped Tony, 'they've got lots of photographs of us boys.' He wore a multi-coloured waistcoat which Ann had made for him; he glowed like a peacock. Rockin' Rex, the rare record dealer, set up his stall in the corner. Pete Barnes arrived to see some young Teds bopping alone. 'They're plastic ain't they? Melt when the heat's on. Buy all the drapes outa second-hand shops and think they're the boyos. There's too much money about nowadays. These scruffy cunts rolls all over a floor in 'em.'

'In the old days, you 'ad to work for it. Money was low; you 'ad to work for it. It's like you looked after it. It's like don't you tread on my blue suede shoes, 'cos you 'ad to work for 'em.'

Tony — 'Icy', after *Toni*bell *Ice* Cream — said, 'You can allus tell a bad drape. It's got a fucking great seam down the back, like someone slashed 'em wiv a razor.'

At weekends, Pete and Icy head out to the coast at Southend. 'Pier Bar. Yeah, go down Southend, Bank Holiday Monday.'

'Bank Holiday Monday, that's the Teds' day, that is. Any Bank Holiday really.'

'We stick together 'cos there's not many of us left now. How much trouble have you seen? Fuck all. You go into a Teds' place, don't know anyone, there's allus someone'll nod to you. Smoothy bastard goes into smoothy bastards' place, don't know anyone, no-one wants to know him.'

Dee and Gee danced together. Dee has been a Ted since she was twelve.

'These folks today, they wear shoes that look like the shoes that cripples wear.' Then the fighting started. Three long-haired men, wearing sleeveless denim jackets with Hell's Angels insignia, had been dancing, drunk and rolling on the floor.

PETE BARNES: 'They were making a lot of noise; we couldn't hear the music, which is what you come for. Slim went over to tell 'em to shut it. They threw a bottle at him and missed.'

At the sound of breaking glass, Tiff and Jacko went over to sort it out. A glass hit Tiff right in his Joe 90 specs. Two of the Angels dragged the third swiftly out, his arms flailing. Tiff and Jacko followed them. The Angels were waiting up an entry, over a wall, and called them names.

DEE: 'They picked up my glass and threw it at someone.'

GEE: 'And mine. My glass, they picked up. This is how it happens: the Teds try to stop it and they're accused of starting it.'

Tiff returned.

TIFF: 'I try to stop it and some cunt smashes a glass over my head. I'll have their fuckin' motor away.'

'They came on a bus.'

CRAZY CARL: 'I'll get my hound out. I've got a hound in my motor. I was minding my own business and this Tom and Jerry started.'

PETE BARNES: 'Them Greebos, greasy bastards, it was them who started it. Them greasy wankers, all they can do is call folk names.'

The Loft

It was in High Wycombe that the first self-appointed King of The Teds met his demise. Desmond Turrell, then twenty-five, appeared before High Wycombe Magistrates in September 1956. It was alleged that he had travelled over from Reading, where *Rock Around The Clock* was banned, to see the film; after the film, he and his twenty-three strong gang caused trouble in a pub; a police Inspector Currell told them to move on; whereupon, Turrell thumped Currell in the eye.

The town is quieter now. The Teds gather on Tuesday nights at 'The Loft', a room upstairs in the Nag's Head pub. D.J. Wildcat Pete, who looks like Buddy Holly, runs the disco: 'Yeah! I performed on that one. (He raises his shirt.) Look at that lovely chest: I used it as a washboard. Yeah, right, if you want to throw bottles at Flash, make sure they're full ones, right.'

Fifties Flash had finished his guest D.J. spot and stood at the bar.

'Bruce, yeah, Uncle Brucey, Daddy's goin' Batty. That's his name: Batty, right. And it's from Sexy Rexy's record box, right.' (Rockin' Rex and Crazy Carl, the rare record dealers; Rex drives Carl crazy with his box of rarities.)

'Yeah, *Sweet Rock 'n' Roll Baby*, Gene Vincent. Next week, we're gonna have a guest D.J. we've never had before: Pete Rawlings from the 1955 Rock 'n' Roll Disco. Thatsa sorta Hemel Hempstead way. He'll be down here next week, ha ha. I don't know what his proper name is or his kinky name is, ha ha. Anyway, he'll be down here next Tuesday.'

'Three cheers for Carl!'

'Yeah, ha ha ha, three cheers for Carl. Oh dear, oh dear, oh dear. Anyway here's one:
ONE TWO THREE O'CLOCK, FOUR O'CLOCK ROCK...

ROCKIN' REX: 'I make a living like. Some nights are really bad but Friday was a good night, you know. Mind you, it's not all profit, is it? Some weeks good: some weeks bad.'

WILDCAT PETE: 'Yeah, right now, yeah. That Daddy himself. WHAAT. We couldn't invite him along tonight, but next week... Wild Wedding Week... Tuesday and Saturday... WOW... We're gonna have a session before. We gonna have a special party, us in rubber gear etcetera. TRUE... Thatsa Tuesday night, right.

'Thatsa Tuesday... Wild Wedding Week. OK. Alright, yeah, ha ha. Natrillee, I'll be having my oats as well, you know. Tell you what, the Weddin's gonna be absolutely astro; it really is. With Old Bruce there... If you don't know Bruce, then you soon will, if he turns up. OK OK OK ha ha ha. So I'll see you next Tuesday night, OK. So Pete Rawlings from the 1955 Rock 'n' Roll Disco, he'll be there. Thanks to Fifties Flash for being such a fantastic guest D.J. tonight, yeah. Cheerio... Whoopeee!'

WE'LL FIGHT AGAIN
THIS TIME WE'LL WIN
WE'LL FIGHT AGAIN FOR DIXIE.

WILDCAT PETE: 'O Yeah, another week of this sun and we'll all look like 'em, won't we? Oh dear, oh dear, oh dear, oh dear.'

BUBBSY: 'Whoopee! They're Rebels and they hate coons.'

FLASH: 'It's no good asking me about this. But you hear all these rumours about who these singers really are. They're well-known Country and Western singers recording under the name Johnnie Rebel. But you won't see *me* playing one of these. I play all four corners of Rock 'n' Roll — the only way I categorise it is it stopped in 1962 — but I don't play this sort of thing.'

Flash pursues Rock 'n' Roll authenticity. 'Bands like Showaddywaddy are regarded by audiences at Rock 'n' Roll Clubs as, shall we say, a bunch of pseuds — Plastics. There are bands who do clubs and are quite accepted. If you want to listen to a good band, listen to Crazy Cavan.

'Shakin' Stevens in the early days, people wouldn't have heard of Cavan then. They'd have said, "there's only one band to hear and that's Shakin' Stevens and The Sunsets." But Stevens got their own Tom Parker, a bloke called Legs Barret. Legs got them on the college circuit and that's the ruination of any Rock 'n' Roll band because they play what the freaks like. I don't blame them, bloody hell. They'll never make any money playing Rock 'n' Roll clubs because the clubs are run for love. They've got to be; it's sheer bloody-mindedness that keeps them going.'

Wildcat Pete finished the session with another Johnnie Rebel record.

Bubbsy did it from Toddington Services, on the MI Motorway, to the roundabout in Hemel, in thirteen minutes.

BOSTON MASSACHUSETTS... PITTSBURG PA.

'Black Horse over Leighton Buzzard. Few drinks in there. Left there, up to Toddington Service. Six of us with the driver. Up for a laugh with the wogs and that, you know. Great fun. A few cracks in there and then a go on the machines. Blast off from there about half-past two. Gets back to Hemel Hempstead, on the roundabout dead, just over thirteen minutes. Dead straight, white lines on the road, can't miss 'em. You get a chance to do it; you do it mate. And the car was only working in three gears and a busted wishbone. In Hemel, we get the old boys, the Original Teds, come up to us and ask for a drink and have a good chat with us.

'So we stick around the main areas and show the bums that we're still around. Been in a few pubs and the old boys come up to us and say, "You know, we like this gear mate. Mind you, our time, I was wearing so 'n' so. Half-collars of velvet, no velvet on the cuffs, no velvet on the pockets, just half-collars of velvet and the beetle-crushers."

'Beetle-crushers: micro-cellular soles. But you get these geezers, smooth guys, they come up to us and say, "We'd dress like you but we ain't got it going. Ask 'em why. "Well", they says, "You get too much trouble with the Smoothies" — the modern geezers. We turn round and say that we don't go looking for trouble: we don't get it unless someone starts with us. They don't believe us.'

FLASH: 'In the Fifties, the Teds were the Skinheads of today. Quite honestly, the Original Teds were nothing but trouble. We've been trying to live down their reputation for twenty years.'

TIFF: 'There wouldn't have been half as much trouble if the *Daily Mirror* hadn't decided that cinema seats were the thing to slash up.'

FLASH: 'That's all they remember about the Fifties, stupid bastards; they forget the music. Shakin' Stevens came out with a badge that summarised it classically:

"Shakin' Stevens and The Sunsets — Heterosexual Rock 'n' Roll."

'It's a man's music. It is a man's music. O.K., you get the kids coming down. The guys coming down, the girls are with them. That's how it's always been.

'Women's Lib's O.K. but you won't see anyone walking over one of our girls. But as far as opinions go, most of the girls leave the blokes to do the talking which, I think you'll find, most Teds are pretty good talkers anyway.

'We're what the Hippies tried to be: we look after our own.'

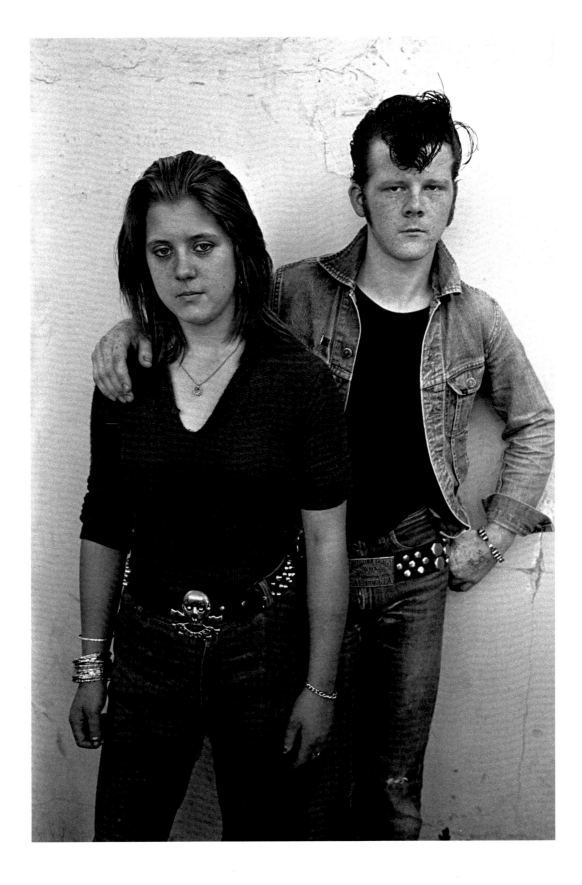

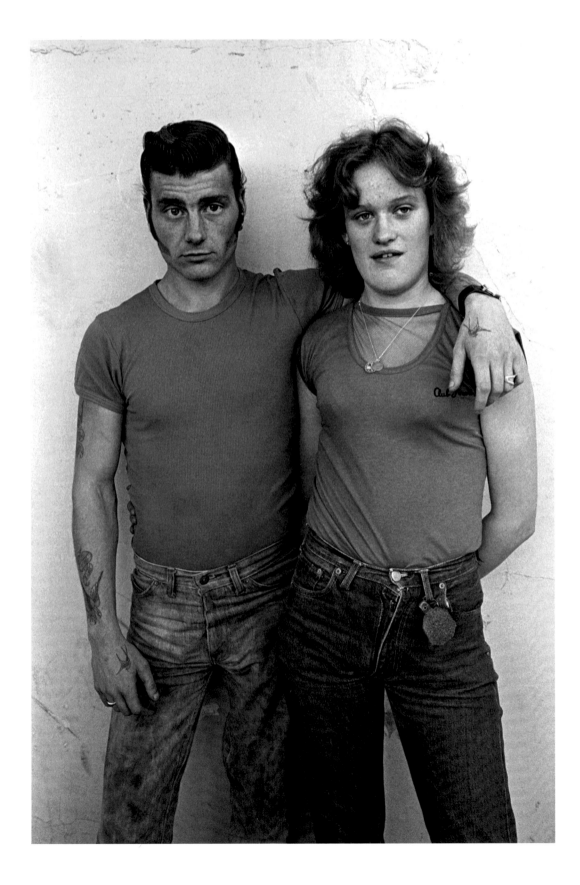

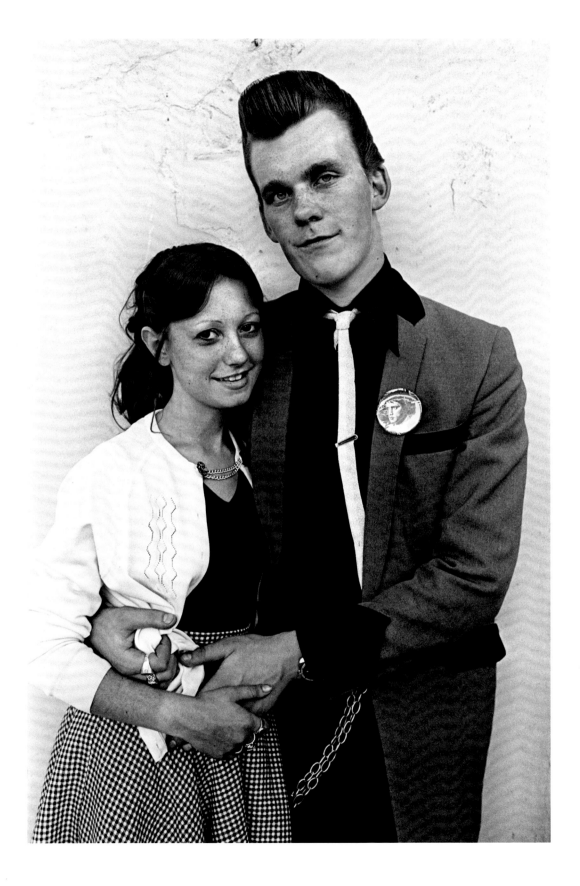

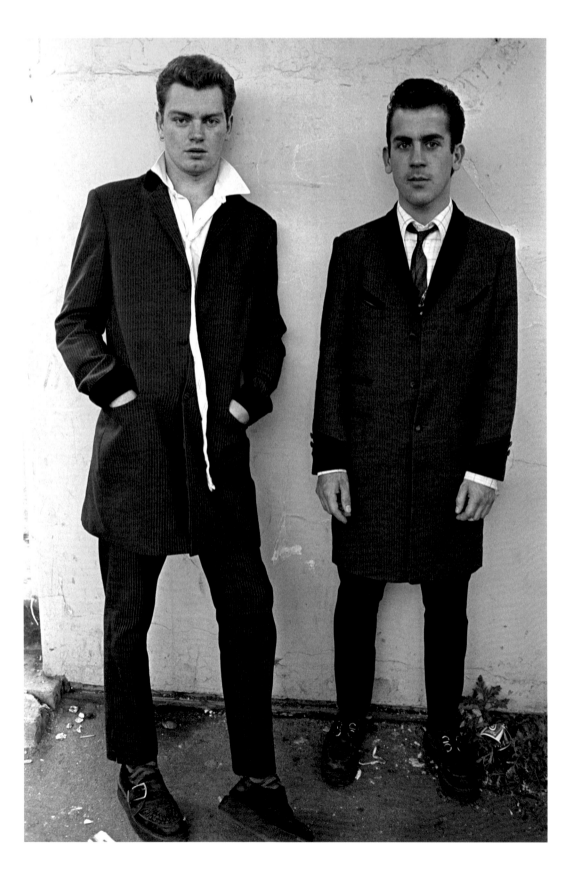

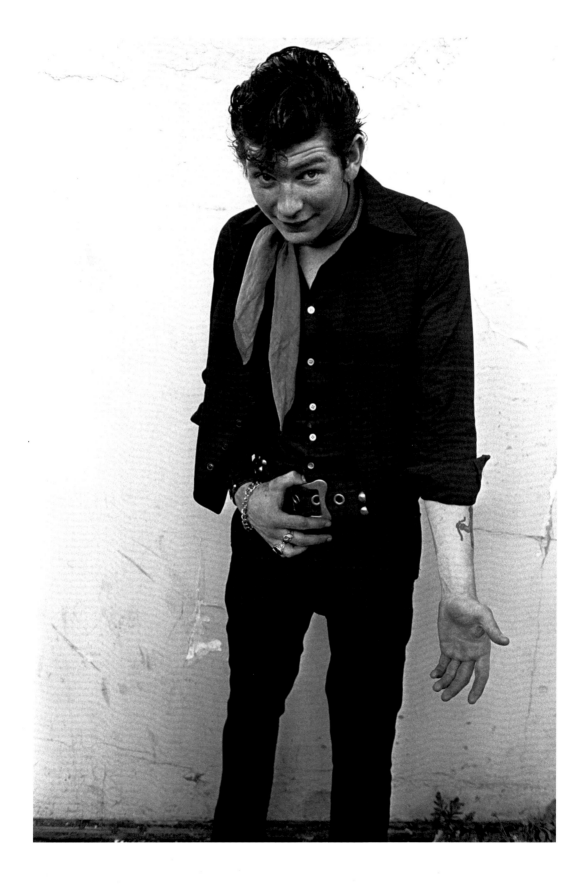

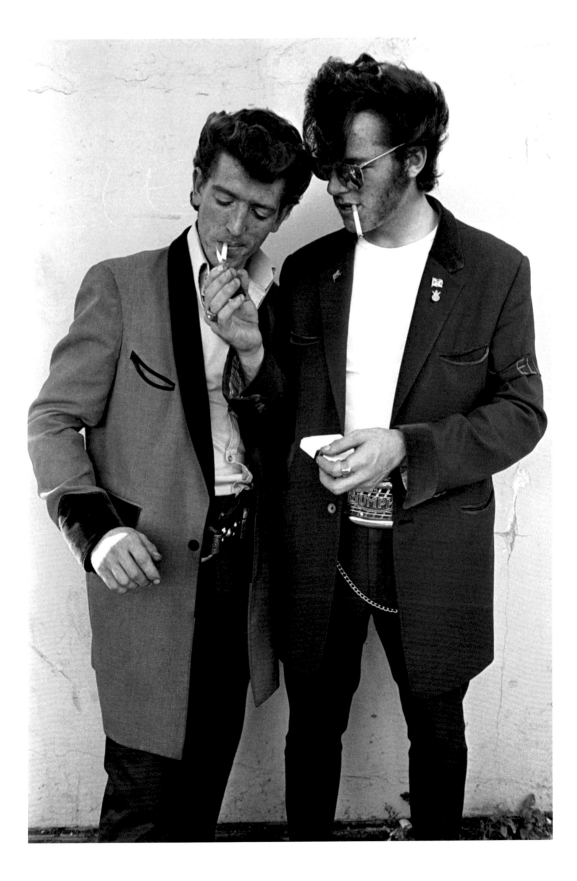

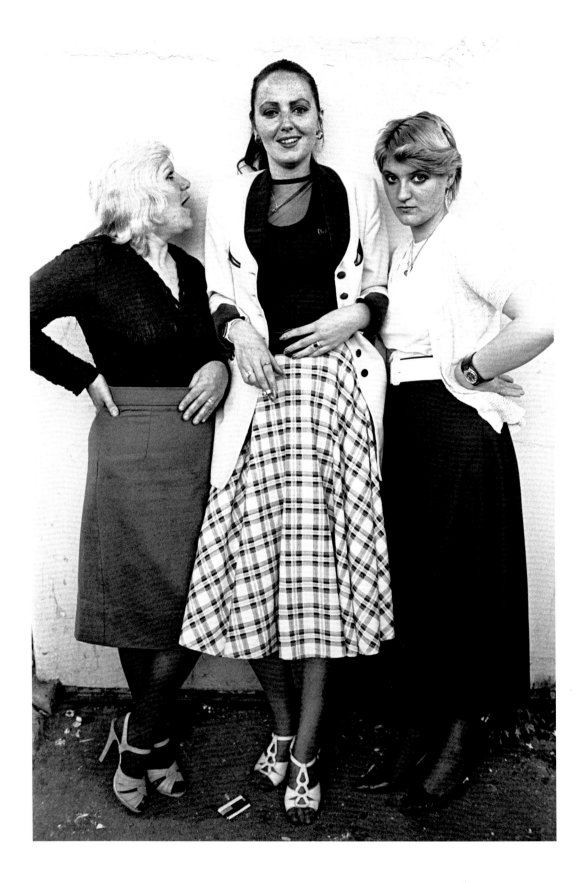

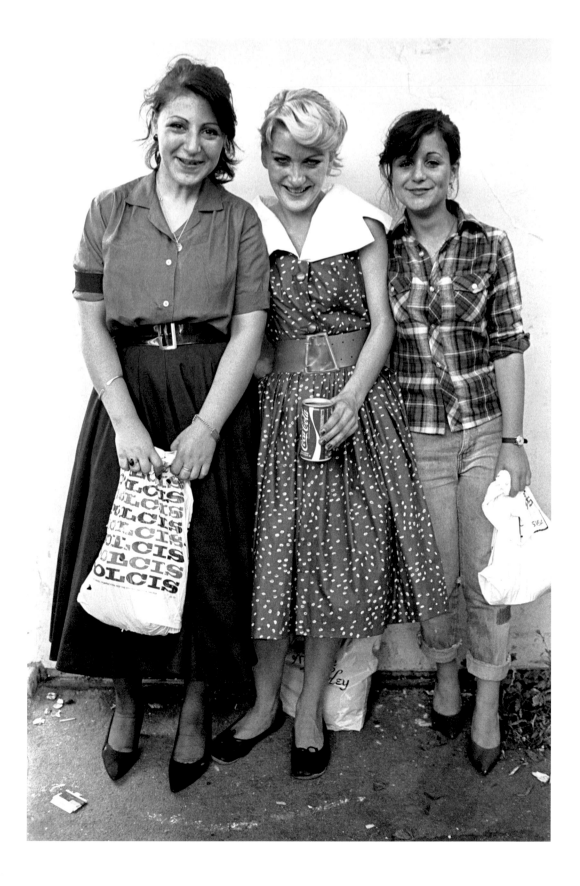

Heatwave

A Summer Thursday night, London was in the middle of a Heatwave. At the Black Raven, by Liverpool Street Station, where the London Teds kept it going through the Sixties, there was not much happening. It was being converted to a 'Smoothy' pub. Outside, a Ford Fairlaine 500 parked but there was nothing doing inside: just a slight odour of puke and disinfectant, and Rockabilly on the Joot.

Heatwave, and the time is right for drinking in the street. Down at The Castle, most of the regulars have hung up their drapes; it's too hot. People gather in groups on the pavement. Arms and chests, hawks and angels adorn.

Chris, a young Ted from Deptford, stands framed by the doorway.

'They call me a Plastic 'cos I ain't been a Teddy Boy since 1950, you know. That's what they call Teds who're starting up now: Plastics. Till I'm about twenty-five, they can call me what they like then. I liked Elvis Presley. Well, I couldn't stand him at first but I went round to my brother's and he literally sat on me to watch this *Jailhouse Rock* film. And, since then, I've been hooked on Elvis Presley. So I'm watching him moving about; so I wanted to become a Teddy Boy.

'I hang about; mainly outside pubs, ain't it? My Dad was a Ted but he didn't go round with all this greasy hair, nothing. Short on top, back at the sides. My mum was a Teddy Girl. They all more or less dressed in the same kind of clothes: drapes, brown drapes. She used to wear a brown skirt, brown stilletos, the lot. They don't wear that anymore — use the excuse they're getting old. I don't really know.

I'M GONNA RAISE A HOLLER [10]

'I had to take a lot of slander alone because there wasn't many Teddy Boys in the school like, only one or two. People didn't share our views, so er...

I'LL TAKE MY PROBLEMS TO THE UNITED NATIONS [10]

'...there was punch-ups. Skinheads going round with all this Dr. Martin's. Us going round in drainpipes, we didn't get on all that great. But in the end, we made friends and that, you know, and that's the scene. Anyway, it's all coming back, this Teddy Boy business. I don't know whether it'll be true to form, like it was in the Fifties but groups like Showaddywaddy who do Rock 'n' Roll... There's definitely more Teddy Boys on the streets now than there was two or three years ago.'

REMINISCING

A group of Teds stand round a lamp-post.

'You know how old this coat is? This coat is seventeen years old.'

'No way.'

'Rubbish.'

'You ain't been a Ted seventeen years.'

'I ain't but this coat's been about...'

'Look, mine's worn out more'n yours.'

Seventeen-year-old coat is with his mate Rochdale Dave, a psychiatric nurse from Surrey. Rochdale's hair is in a Silver-Dollar. He sports a brand-new houndstooth-check drape with a black velvet shawl collar. He looks like Chuck Connors.

'I just had this coat made: Blue Rose, Westminster, Army and Navy Stores. I was one when they first started. I was up North then...'

Seventeen-year-old coat interrupts: 'Teddy Boys are the real working-class people who know what decent music is; who know what decent clothing is; and who know what decent people is.

'They're not people who walk about saying, "Oh I'm a Teddy boy." But, what...

Not a Saturday night touch... What a lot of tits think we... Think Teds are trouble: we're not. It's other people picking on us, like the Bill — the Police.'
ROCHDALE: 'If we weren't trouble, they kept picking on us.'

Seventeen-year-old coat: 'Yeah, they kept picking on us. All this load about bicycle chains and that, you know, load of old crap. It wasn't the Teds who smashed up cinemas: it was the Rockers. They blamed it on the Teds because there was a couple of them about. I'll tell you something: Teddy Boys spelt something different; they spelt poverty, Mate. A lot of people you see today go about in eighty-pound suits. A real Ted couldn't afford eight... What was eighty pound for a bloke in 1950? A bloke who hasn't probably started work... Seventy pounds: gastronomic.'

'No way.'

'Fucking wanker.'

'But all these Showaddywaddy people, they're just taking the piss out of something they don't even fucking understand. Most of the records we buy aren't even Rock 'n' Roll. They're what's classed as Rockabilly; that's earlier.'
ROCHDALE DAVE: 'We only found out about Rockabilly second time around because the records weren't available in the Fifties.

Dave Ransome, a hero of the Trocadero in Fifty-Six, one of the Ransome Brothers, had overheard Seventeen-year-old coat. He walked up to him:

'What is a real Ted like? What would he do to an old Ted?'

'I wasn't about then.'

'Well, before you start shouting your head off, about what you are or what you ain't, 'cos you're not a Ted, far from it, right? The only ones who know is us. The fuckin'... Who is the Teds of this area. Yeah, and you're not. You, you're nothing. O.K., you wear... 'cos you wear a drape...'

'We all respect it...'

'O.K., you're s'posed to be the hard nuts.'

'No, we're not.'

'Well, you try to be.'

'We don't.'

'Most of you do. Most of the older Teds...'

'...They're the ones we respect.'

'In the Fifties, we didn't give a fuck about anybody. We used to cut their fuckin' throats. We used to cut their eyes out 'n' everythin'. We done it. That's when you call a Ted. You, you're nothin', tell yer.'

Dave Ransome returned to leaning against the wall. Seventeen-year-old coat shut up.
ROCHDALE DAVE: 'My point of view is if I wanted to wear bell-bottoms, I'd join the navy, then I wouldn't have to buy them. To me, it's the smartest style that ever came out for men; always will be.'

'It's manly, isn't it?'

'Yeah.'

'All you got in the Fifties was your old man's demob suit, handed down to you. That's all you could get off the peg — the Al Capone suits, that's all. That's why the Teds weren't liked: because they did something on their own. We were the first. Let's face it, we were the kingpins as far as teenagers went. First in everything, you see. That's where all the male fashion comes from, from us. The reason Rock 'n' Roll caught on so well was because your parents didn't like it. A Rock 'n' Roll singer was

condemned as soon as he opened his mouth, even if he was only speaking on the radio. If you'd seen him with a guitar in his hand, he was condemned.'

Johnnie, his hair in an enormous quiff, joined us. A record played in the pub.

I'M BREAKING ROCKS IN THE HOT SUN [11]

Someone kicked a glass over. It broke on the pavement. A police patrol car URRRR URR'd blue flashes in the sunset down the Old Kent Road.

I FOUGHT THE LAW AND THE LAW WON [11]

JOHNNIE: 'Don't get us causing aggravation, though; we weren't...'

ROBBIN' PEOPLE WITH A (bash-bash-bash-bash-bash) SIX-GUN [11]

'We didn't. We didn't. It was because we was dressed like we were. And the other people — the way-out people — dressed in baggy trousers, sort of wanted to cause aggravation. That's why we got a bad name because...'

'... And that still happens today.'

'Still happens today. Now, I'll tell you something. See how I'm dressed now: no drape, nothing. I work in London, like. Walking home tonight, people looking at me as though I was from a different planet, as though I was a zombie, 'cos I got a different hairstyle.'

'Does that make you feel self conscious?'

'No. It makes me feel wild. Because if I go into a boozer that isn't Rock 'n' Roll — what we call Smoovies now, people dressed in flared trousers and that; nothing against you mind. And what they do is start looking at us and taking the piss.'

'I've had instances. When I was down at that pub... What's that pub at er... Blackheath?'

'The Green Man.'

'No, not the Green Man, no.'

'I'm sure that was where it started, wasn't it? Near enough.'

'It's a grey sort of place where the 53s turn round.'

'Oh, The Red Cow.'

'No, not...'

'Oh shit, I know the one you mean though... The Mitre? No?...'

'No, no, you know as you come across Blackheath, there's a pub on the corner, isn't there? Smoovie pub, like. I went in there one night, as I was dressed.

'As soon as I walked in there, two blokes and two girls started taking the piss, laughing away, like. "Well," I thought, "Alright."

'I said, "Look, are you taking the piss?"

'He said, "No." Well I knew they was. I said, "Look, jokes-a-joke fuck-a pantomime, I don't take the piss out of you; you want trouble, outside." There was two of them: me, on my own. I took them outside. They didn't want to know. I said, "Look, I don't take the piss out of you; I don't mind a joke but don't take the piss. I dress how I want to dress: you dress how you want to dress."

IF YOU'RE LOOKING FOR TROUBLE...

'If this was 1957, I wouldn't be here now. I wouldn't come into this fucking area, as it was then, Teds like it used to be. I wouldn't be here now...'

'...The Elephant, The Angel...'

'...For a state of a kicking. You kept to your own area, with your own mates. Now, like everyone sort of mingles in together. But you wouldn't be seen out of your own area. I wouldn't come down here, on my jack, in them days.'

ROCHDALE DAVE: 'Well, you can tell what it was like. I was living in a new housing

estate in Rochdale. Turf Hill is another estate up there. Behind some shops on a place called The Strand, there was some old land where they were going to start building. The Turf Hill Lads came down one night. We met them on that land. We had a right battle up there. Because they came from Turf Hill; shouldn't have been over there. But they told us they were coming. As it is now, it's lost its atmosphere a great deal.'

IT'S A FAST LIFE

'Where did you get the drapes?'

'Are you going to make a recording of this speech.'

'Well, you buy 'em in a shop, don't you. Get 'em made to measure or off the the peg.'

'I thought you got yours at Burton's.'

'ORIGINAL.'

'Turn round a sec... Look at that, it is Original.'

'You don't get full-backs at Burton's.'

'I know, that's what I found out when I had the first one made.'

'Well, what is this then?'

'*This Is Your Life*. This *is* your life.'

'What? Are you taping everything we say?'

'*Candid Camera*.'

'...Now here we are today...' (He impersonates a TV newscaster).

'I'll tell you one thing: the best life is a Ted life.'

'Why's that?'

'It's *fast*. It is a fast life. Music, everything... I dunno, I never thought I'd get so many birds.'

'They call you Jimmy, do they?'

'They call me Snatcher Jimmy.'

'Snatcher?'

'Yeah, because I pinch everyone else's birds. You ask any Ted what it is about Rock 'n' Roll he likes. What is it?'

'Eddie Cochran.'

'The beat. The beat. The music. The back-beat. The drums and bass-guitar.'

'To stand out.'

'The best is Eddie Cochran.'

'Were your Dads Teds, like?'

'My Dad wasn't; my Dad was in the Al Capone gang...'

'...You look at these smoothies today: just a load of fucking puffs...'

'Your sort of Al Capone style.'

'My Dad was Ted; still got the records to prove it.'

'It's the CIA; it's the KGB.'

'Listen to this record.'

YOU DON'T BELONG IN DIXIE

'That's American.'

'My Dad's American.'

'I don't know about your Dad, I'm American.'

'Yeah, 'n' I'm Japanese.'

'What are your names?'

'Myra, known as Steamer. I got that name from two things: one from fighting, one from smoking.'

'Whilst she's fighting, she steams around the ears.'

'Sandra.'

'Big Jim.'

'Billy Fury.'

'I just bought the gear. I like the music. I was brought up with this sort of music.'

'I'm George, otherwise known as Spider.'

'This is Larry.'

'I went and saw *That'll Be The Day*. I liked the drapes. I heard the records they was playing. I thought, "It's not bad, this stuff." So I went home; took my trousers in; started looking through my Mum's records; found a load of old Rock 'n' Roll. I'll tell you what, first impressions of a Ted, I ever had, "What a stupid idiot; those drainpipe trousers; all that grease he puts on his hair."

'What do you put on your hair?'

'I put a whole packet of lard on my hair. Lard in this weather, it just melts in the sun. I put lacquer on.'

'What about Brylcreem?'

'No, no good.'

'Water and sugar.'

'Bees like that.'

'That's what they used in the old days: water and sugar.'

'What do you call the bit at the front? The Elephant Trunk?'

'Nuff of the elephant trunk. It's a quiff. Quiff at the front, D.A. at the back.'

'What sort of work do you do?'

'Me, I do stewarding at a hotel.'

'I'm a fitter and welder.'

'Engineering.'

'He's a window-cleaner.'

'Did you get to know each other through Rock 'n' Roll?'

'I have never seen this guy in my life before, except tonight.'

'I've never seen him before. But I'll tell you for one thing, he's a Tinnuc.'

'Thank you very much!'

'A tinnuc?'

'I can't, you know, translate that. It's not a very nice thing to put on a tape recorder. In other words, he's a C-U-Next Tuesday.'

'He's a Plastic Ted.'

'You can tell by those Bay City Rollers' socks.'

'Gerrout of it!'

Closing time came around again. They left laughing. A couple sat kissing on the bonnet of a Zephyr Six. Behind the bar, Sunglasses Ron, King of The Teds and President of The Confederate States of America in Exile, rolled up his shirt sleeves to wash the empty glasses. He revealed the tattoo:

NEVER TO BE FORGOTTEN

BUDDY HOLLY

And, on his left bicep, a tattooed tombstone:

EDDIE COCHRAN

17.4.60

RIP

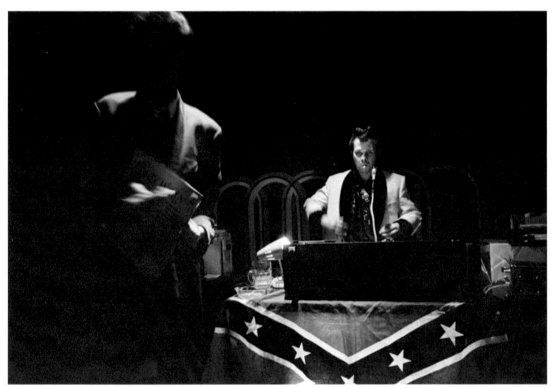

Fifties Flash

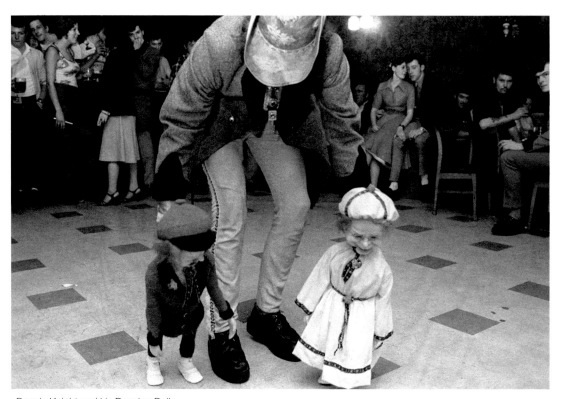

Dennis Knight and his Dancing Dolls

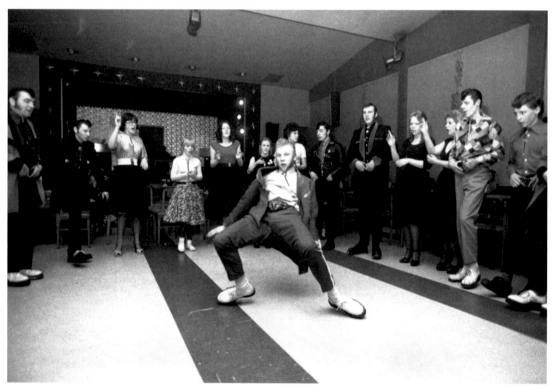

Hull

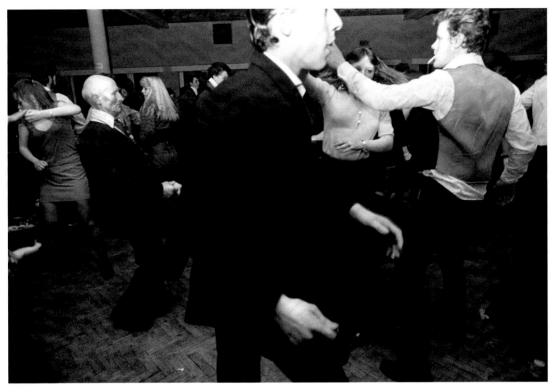

The Queens Hotel, Southend

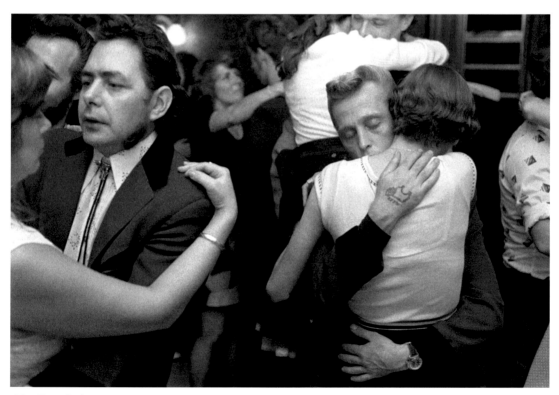

Blue Boar, Derby

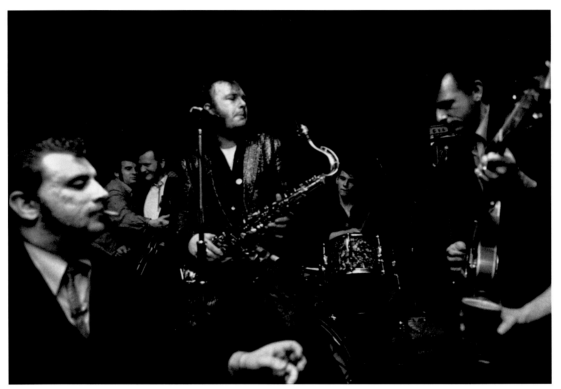

The Riot Rockers

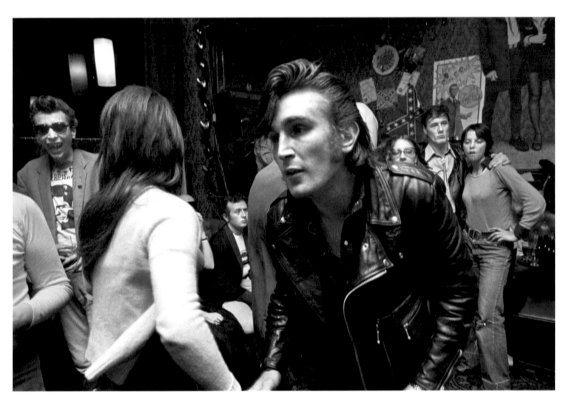

The Castle, Old Kent Road, London

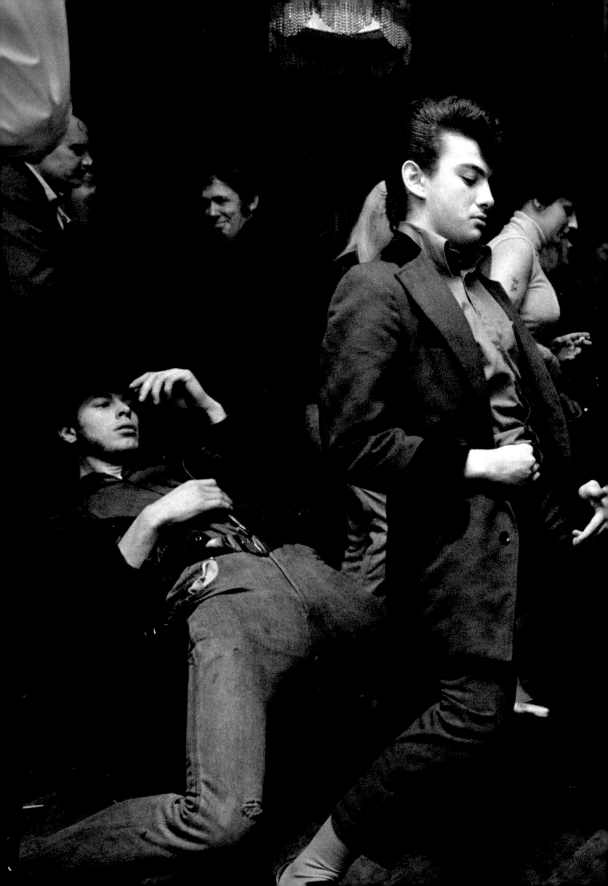

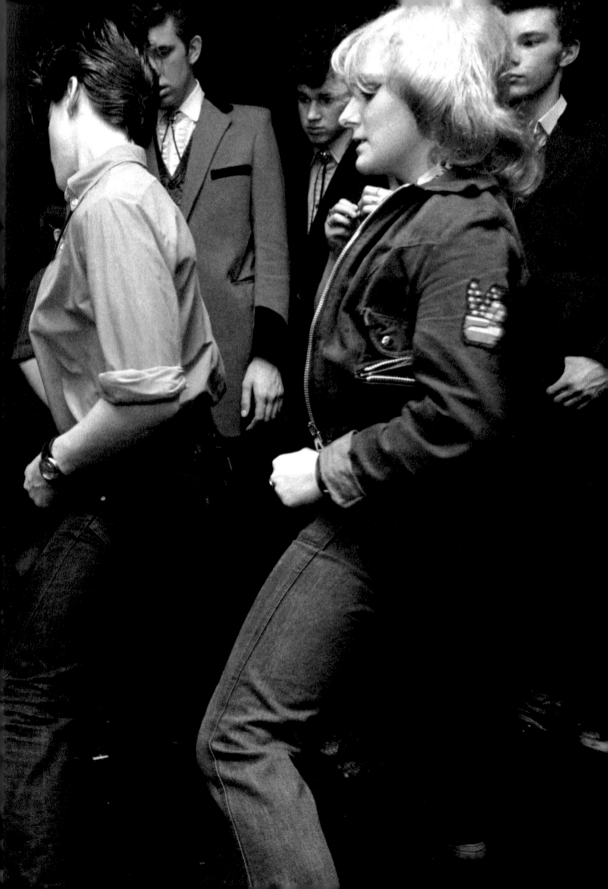

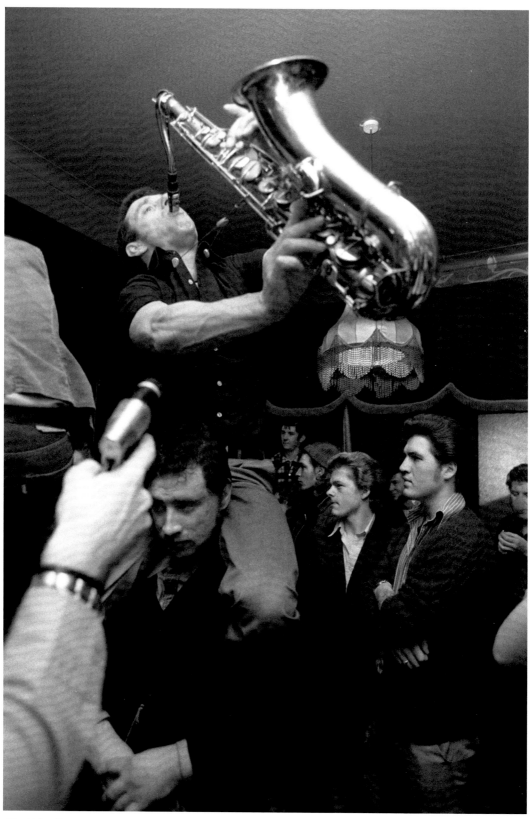

The Flying Saucers

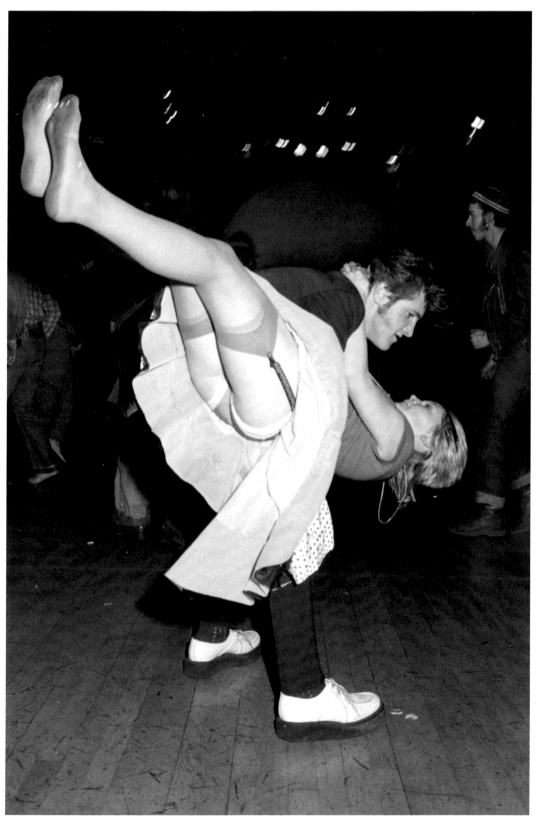

Lyceum Ballroom, London

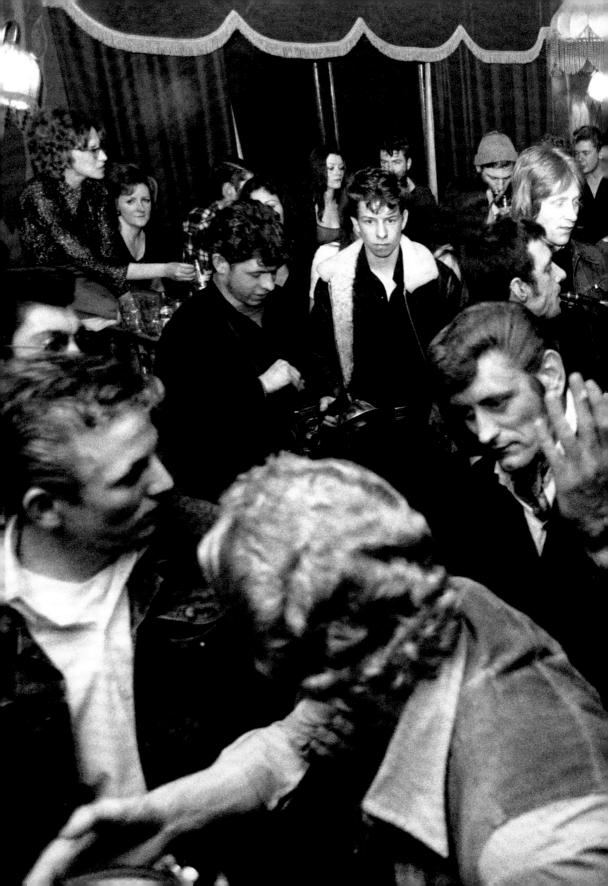

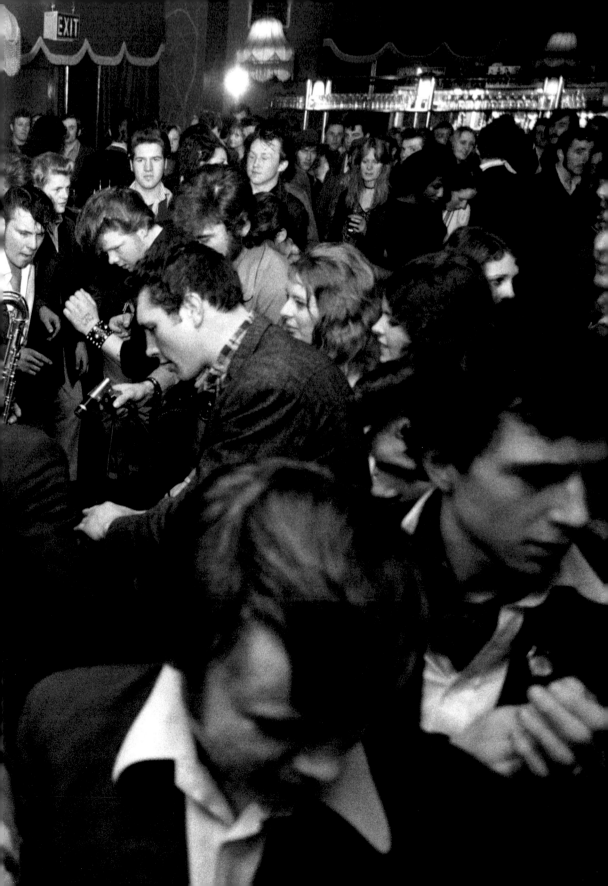

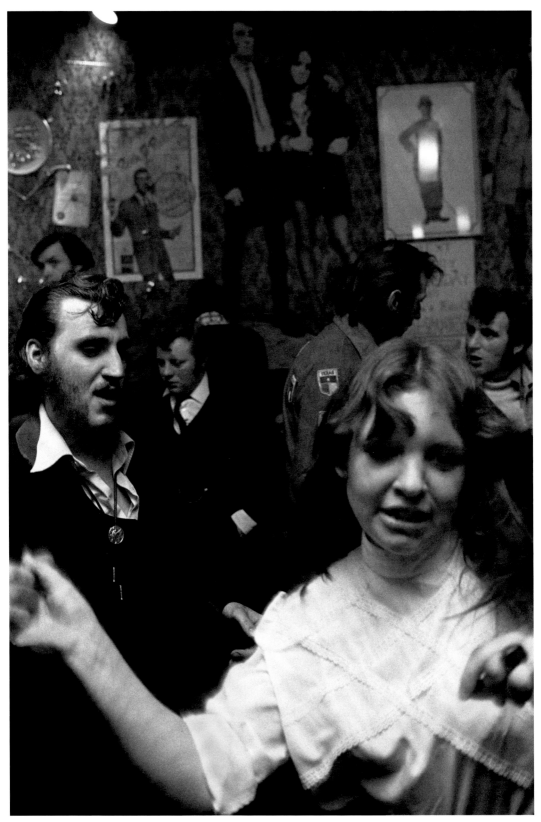

The Castle, Old Kent Road, London

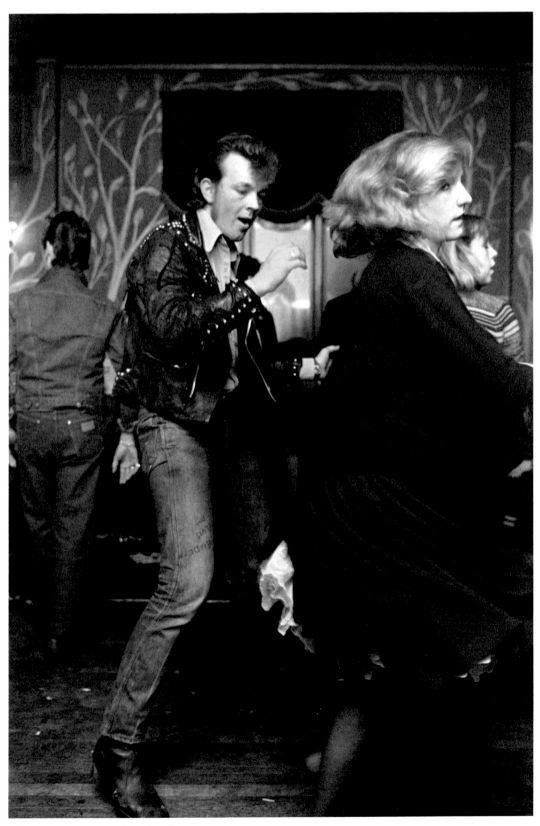

The Adam and Eve, Hackney, London

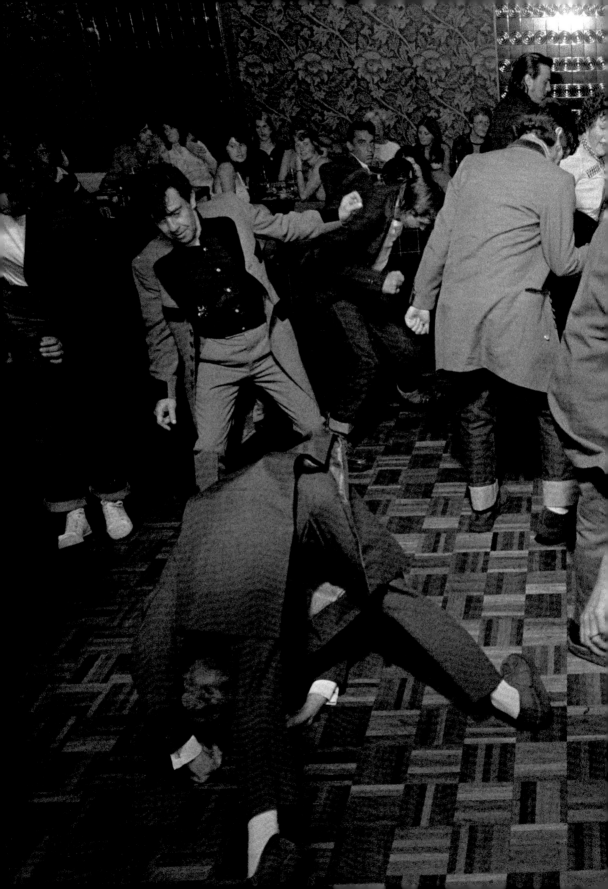

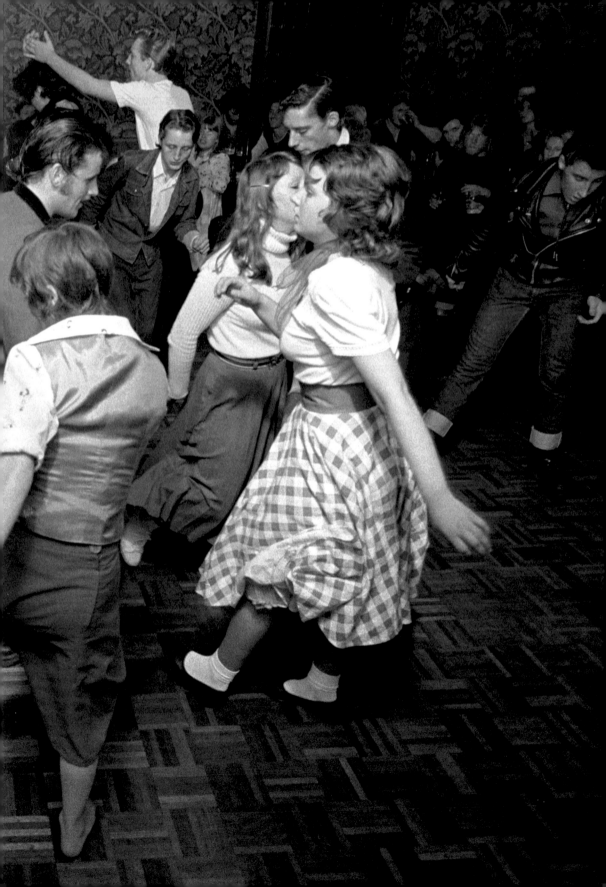

Big Night Out

Teds love coach trips, the sense of occasion. Crazy Cavan and The Rhythm Rockers were playing the Mecca Locarno at Portsmouth. Cavan are a top act on the Ted circuit and dance-halls are a favourite Teds venue.

The coach left the Lyceum, London, for the Locarno. The pilgrimage to Mecca, it was 5 p.m. Twenty quiffs pointed towards Pompey, like the prows of Viking ships sailing on the evening tide. Rows of Ducks' Arses, Pony-Tails, and Beehives rose above seat backs. Rockabilly music played over the loudspeaker as the coach crawled through the rush-hour traffic.

Icy sat alone; he had things on his mind:

'Started off, like, I was riding my bike. No L-plates, no lights, nothing. What I did was give a false name and address — I thought I'd get away with it. Reported it nicked down Peckham: got booked in Kennington.

'Three or four months later passes, there's a knock on my door. Saturday morning, about nine o'clock, it's the Old Bill down there. It's the same copper. I walks down the stairs. He says to me, "Recognise me, Son?"

'I said, "No."

'He says, "I'm the bloke who pulled you up, recognise you by the earrings."

'I thought, "That's funny," 'cos I had my crash helmet on all the time. He knew it was me, so I gave up in the end. I'm up at Blackhorse Road on Friday.'

Icy had recently had four earrings in his left lobe replaced: 'Had some of 'em ripped out in a fight outside The Castle. Smoovies... Bit of trouble... Took the piss, one of them, like... Had a few drinks... Went into all six of them. Anything for a laugh.'

Cowboy-hatted Andy travels all over England for Rock 'n' Roll. 'Came down to London on the National Coach. I set off from home, seven o'clock this morning. Then, down to the centre of Bradford. The coach set off at ten past eight. I got down to London at about one o'clock. And, as yet, I haven't had any bloody kip.

'Fortunately for me, one of the lads down here, Ron Staples, he's putting me up for the night. I met him when I came down to the first and only Lyceum gig I've been to. That was October last year. And that had Cadillac, C.S.A., Matchbox, and The Hellraisers on.

'Now that was a very special night for The Hellraisers because it was the nearest they could get to the date when Gene Vincent died. All that night, they played mainly Gene Vincent material, which was great, because, in my eyes, the greatest Rock 'n' Roll star ever was Gene Vincent.

'From Keighley, there was Brummy Pete and Bopping Bill — it was his car we came down in. It was a bloody big black and gold Oldsmobile F 85, big Yanky job, with a smashed in windscreen; you could just about see through the cracks. And me and Chip from Bradford.'

Fifty miles from Portsmouth, they stopped for drinks at the Green Man. Icy and Sunglasses Ron sprinted for the pub door. The Landlord met them with a triumphant smile: 'No coaches.'

'Right, back on board.' Our desperados finally found refreshment in the White Lion. Zodiacs and Zephyrs descended on a deserted Portsmouth city centre, Monday night in Winter. Shop signs shone on the damp streets and the warm neon glowed Locarno.

Shazam, a local band, played and fulfilled their teenage fantasies. They went down well with the local Teds. Pete Presley, the young singer, looked older. His loose fitting grey zoot suit looked fawn under the yellow spotlight. He had a Fifties B-feature psychopathic quality, high-school confidential disturbance. A million miles from anyone, a young man who had never been young, out on the streets again.

'Ginny, Ginny, Ginny, with a red dress on...' Greasy blonde quiff, muscular brutality, wounded.

Pete took his image from Elvis. There have been many Elvis imitators; all the early English Rockstars, Cliff Richard, Tommy Steele, Billy Fury, reveal the Elvis lineage. There are those like Pete Presley who want to go further: to be Elvis.

Most notable amongst the existential Elvises is Vince 'Elvis Presley' Taylor. He had a hit in 1962 with *Jet Black Machine* and *I'll be Your Hero* and later recorded *Brand New Cadillac*.

In the late Sixties, there was Rockin' Rupert, a dead ringer for Elvis, who used to merely mime to Elvis records at concerts. He fitted the camp consciousness of the time. There is Alan Meyer, America's top Elvis, who earns 20,000 dollars a week. Then there were the Elvis impersonators who held a convention in Dusseldorf.

In the 'Gentlemen's Stag Room', through the mirror lined foyer, Teds resculpted quiffs in front of giant mirrors. The cloakroom attendant sat in his kiosk, reading the race card of a horserace that had already been run.

Onstage, the crucifixion of Narcissus continued. Out of time, smile-Jesus-loves-you faces of the light-show drifted behind the band. Multi-coloured light-bulbs swirled like a fairground waltzer. Teds jived but mainly drank. The Assistant Manager, twenty-six years in The Marines, stood in his tuxedo backstage, drinking coffee; but it was his kind of music.

The Riot Rockers, a Ted band from Grimsby-Cleethorpes, wound their way through a Rock repertoire. Ray, the guitarist, had a tattooed throat — a wreath of flowers — the ultimate initiation. He seemed suddenly vulnerable. Oggy, their roadie, sold records and gave away photos at the back of the dancefloor.

The Brighton Boys came down in a seven car convoy. Paul wore a brass model Colt 45 and Holster medallion around his bootlace tie. The gun comes out of the holster. 'Got it at some dive in Brighton.'

He shared a car with the Harrington Brothers, Derrick and Dave. Dave is no longer a Ted: 'I've started riding a bike and, if you've tried to get your helmet over a quiff, quite difficult. Use grease, it just slides about on top. And, if you use lacquer, you can't get it off.

'You walk down the main street in Brighton and everybody goes, "Err, Bloody Hell, look, oo." They take the piss out of you.

'The old Teds got a bad reputation in Brighton. Everybody thinks we're all the same, no joke. They think, "Don't say anything or you'll get duffed."

'It's usually peaceful here, though, trouble's all in the past.'

'No point in having aggravation if you go to a decent place, is there?'

The South Coast Teds, bright drapes, orange and reds, with half-belts; Brenda and Kim, two girls down from London, didn't rate them: 'All the people down here, they're not proper Teds; they're just acting the part for the night. They're not even

acting it well: they're Plastics.'

'Look at him! He's wearing plimsoles, with his drape, just not on.'

Ray, from Brighton, is the Ted with plimsoles: 'I knew you were going to get round to the plimsoles sooner or later, everybody does. I had a pair of creepers —1953 ones — but the bits of cork started dropping out.'

From Worthing, the Hazelton Family came down for the night: Russell, Gary, Dave and Dave's wife. Dad Den is a Ted too; they'd driven down in his four-twenty Jag. Dad got it going and the boys followed suit. The family that rocks together.

Crazy Cavan and the Rhythm Rockers played their own Rockabilly songs. They finished the session jamming with the Riot Rockers and anyone else who went up on stage. All Teds are stars. Teds and girls linked arms and rocked to and fro.

The lights went out in the 'Sapphire' and 'Crystal' bars. In the small hours, the rocking had to stop.

The coach sliced the night through the blackness of strange lanes. The irregular lights of an unknown town shone on the black distant hillside. White chevrons round the bend. There was the occasional slight laugh or the muttered exchange of tired lovers. In the dimmed light, a woman stroked her man's brow as his head lay in her lap.

The hum of the Ford Diesel engine changed with the contours of the landscape. The moon hung low in the sky. Soon the motorway.

Marching

D J. Stu Coleman, from The Castle decided that there was not enough Rock 'n' Roll on the Radio so he organised a petition asking for more Fifties Rock 'n' Roll. With the help of Sunglasses Ron and other interested parties he collected 80,000 signatures from Rock 'n' Roll clubs throughout the country.

On a Saturday in May, 7,000 Teds and Rockers joined him to march on the BBC. There were quite a few American Dreamer teenagers, too. Young Jimmy Deans, dressed in denims and young girls with pony-tails in Bobby Soxer styles.

Ten coachloads came down from Birmingham and three from Glasgow.

DERBY TEDS
SHAKIN' STEVENS AND THE SUNSETS FAN CLUB
RISLEY ROCK 'n' ROLL CLUB
JUSTICE FOR ROCK 'n' ROLL
ROTHERHAM ROCK 'n' ROLL SOCIETY
SOUTHEND ROCK 'n' ROLL REBELS
CHICHESTER

They assembled at Hyde Park. At the front, an old lady, dressed in an American Civil War surplus Confederate uniform, carried a Confederate flag. Other stragglers from the same war surrounded her.

'Yippee!' shouted a Ted, 'It's the Johnnie Rebs.'

Behind the Confederates, came a lorry carrying the Flying Saucers. They played the march forward with *Fabulous*, an old Elvis Presley hit. The lorry carried posters advertising the Saucers' new album, *Invasion of The Planet of The Drapes*.

Stu and Sunglasses Ron marched up front. Stu carried a box containing the petition and a demo-tape: *The Ark of the Covenant*. Marching with them was Screaming Lord Sutch, the greatest Rock 'n' Roll politician of them all.

Sutch wore his leopardskin leotard, in which he was once deported from Orly Airport Paris, and a gold lamé top-hat. He had an acute awareness of the presence of cameras and, at the slightest sniff of a lens, his topper was raised to reveal a broad grin.

Sutch, Master of Publicity, he twice took on Harold Wilson at elections, as National Teenage Party candidate: he was twice defeated. He once had a busload of girls streak down Carnaby Street.

To publicise the march, he had planned to sail a piano down the Thames but it sank when he pushed it in. Lord David Sutch in fine form: 'It shows what lengths people will go to for their music. What other sort of music would go to these lengths? I've always done Rock 'n' Roll — over twenty records. You've got to go to extremes because we've been writing in for five years and they've ignored it.'

Many of the rockers left over from the early Sixties were there, leather clad, the permanent ton-up boys: United Bikes GB., The Road Rats, The Hell's Angels, and The Horncastle Hell Cats.

The march met a slight drizzle on Oxford Street. The Teds emitted the Teddy Boy Roar.

Stu delivered his petition. He was pleased with the way it went. 'It's fantastic: they've come from all four corners of the Country. We expected a good turnout but we didn't think it would be this good. If the BBC don't listen to this, they won't listen to anything.'

The BBC did listen; three months later, Stu and his partner, Geoff Barker had their own Saturday night Rock 'n' Roll radio show, *It's Only Rock 'n' Roll*.

On Saturday night, after the march, there was a commemorative concert at Pickett's Lock, a large council gymnasium in North London. It was promoted by Lee Allen, agent for the Flying Saucers, Crazy Cavan, and The Riot Rockers. A big night to round off the big day. Pete Barnes was unimpressed: 'I'd be a lot happier if there was a lot less Plastics about. It's the Plastic Teds that cause the trouble. I wouldn't call them Teds: they're wankers.

'You come here, a fuckin' Ted wants to search you at the door — fuckin' cheek. All these fuckin' yobboes keep walking across the stage to get themselves noticed.

'They ain't got no light and bitter — fuck that. Plastic glasses for your beer.

'Lee Allen, the bloke's a comedian. We're fuckin' paying for him to drive round in his Mach 1 Mustang.'

A Ted walked up on stage: 'I'd just like to introduce myself: I'm Rockin' Johnny Allsop. If anyone wants to fill me in tonight, I'll be waiting outside.'

'Hurray!'

'Fuck off.'

Screaming Lord Sutch acted as Master of Ceremonies. He introduced the star Teds to the audience. 'Tongue Tied Danny!'

Tongue Tied Danny, Ted D.J. and a veteran from Kingston, took the stage. 'Rock 'n' Roll is here to stay.'

Sutch moved quickly and slickly. 'Yeah, Rock 'n' Roll's the greatest sort of music there's ever been. It'll always be there, we all know that; we all dig it. So how about a big hand for the Flying Saucers!'

A sweaty, tattooed back showed through a sweaty T-shirt bearing the slogan BACK TO THE FIFTIES.

After the Saucers, it was time for Crazy Cavan and The Rhythm Rockers.

'What a load of wankers', someone shouted, 'Rockabilly crap.'

His friend supported him: 'Only Rock 'n' Roll. I hate this Rockabilly rubbish. It wa'n't good enough then and it ain't good enough now. Rockabilly's a load of crap. We want Rock 'n' Roll.'

A Nottingham Ted shouted 'Wankers' and made a gesture with his right arm.

Sutch left before the end. 'It's been a good turnout. All exciting and it was well done. It all helps, lovely, the bands are going well. Good atmosphere. All done in a good cause.'

A West London Ted remarked, 'Boys round our way, they'd do anything for Sutch, they're his mates. Whether they'd pay to see him is a different matter.'

Two Teds from Lincolnshire played football with an empty plastic glass. They were Cobblers Jehu and John Bakewell, both approaching middle-age, 'Name's Jehu and it's not Jewish neither it's Welsh. There's a maternity ward in Stamford they're going to call after him: Bakewell, bad bastard.

'We were always basically Teds. But when the drapes went out we used to wear leathers and tight jeans. And he's a bad fucker, Bakewell, got rather bad ways.

The floor was littered with beer cans.

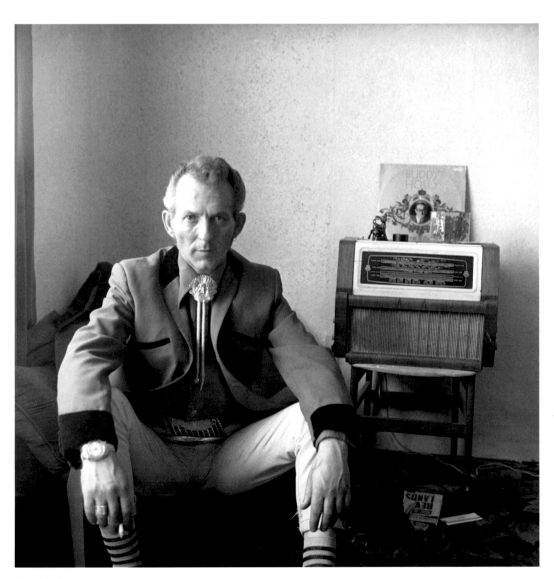

Ken Kilbey

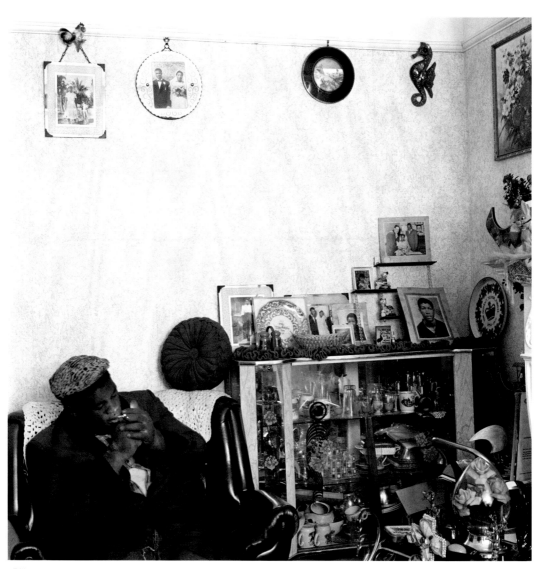

Bill

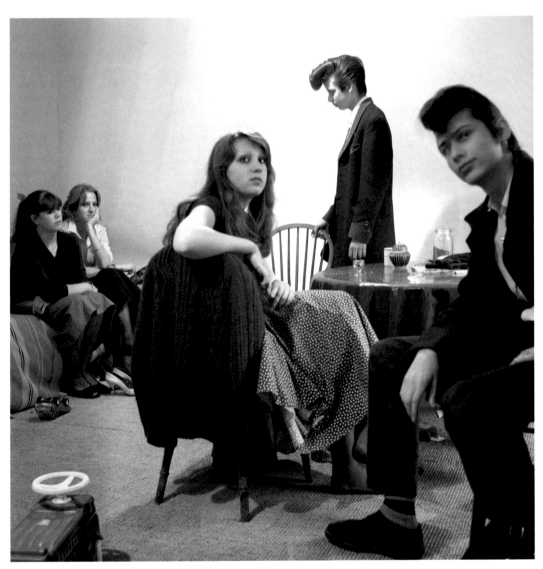

Frances, Kate, Emma, Studs & Ben

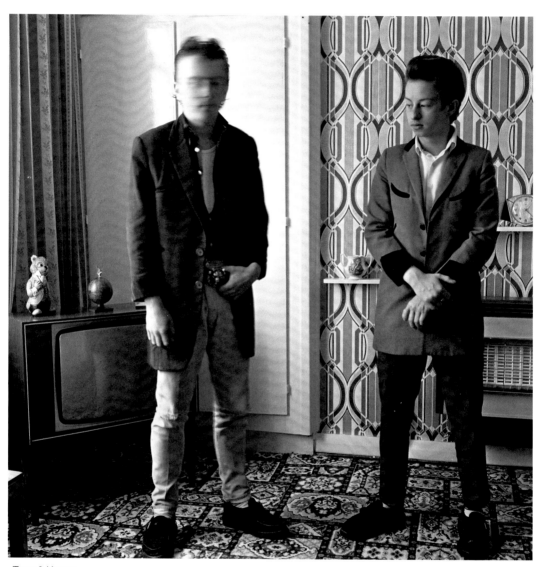

Tony & Kenny

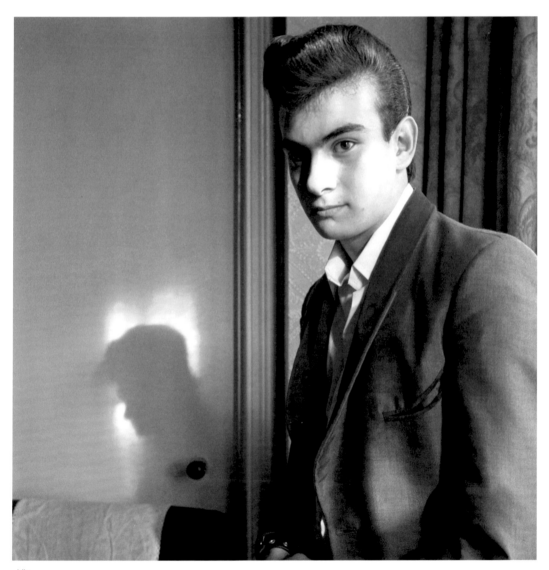

Kip

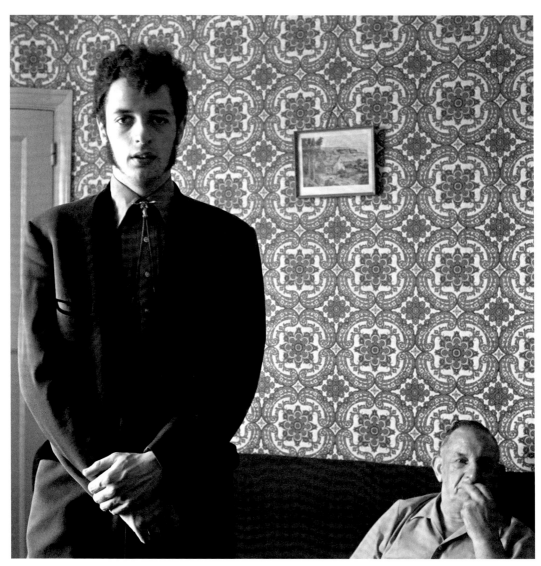

Jailhouse John and his dad

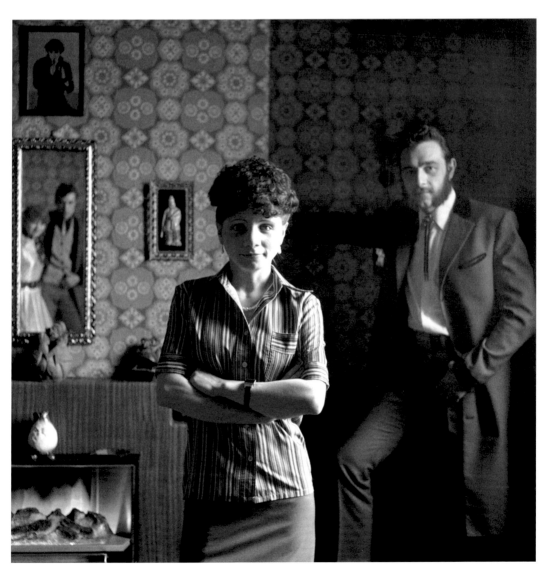

Vivien Brown & Pete Kershaw

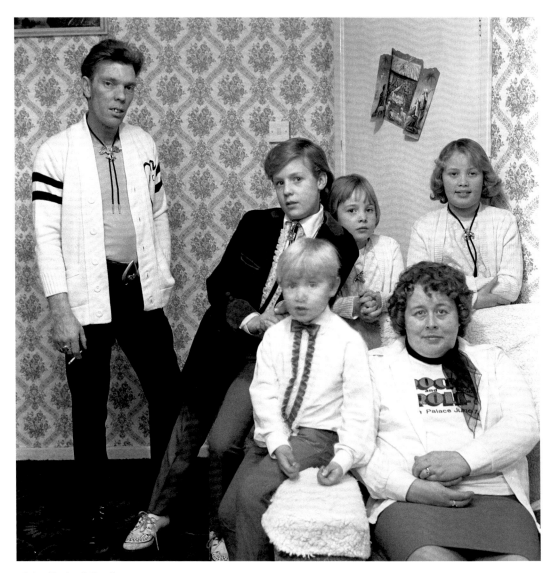

John, Eunice & Family

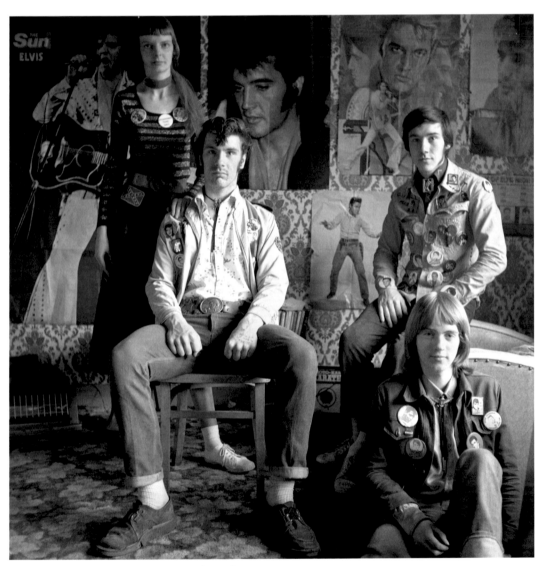

Mr and Mrs Elvis Presley, Billy Taylor and Crazy Cart

Going North

The East Midlands Coalfield, Ted Territory since the mid-Fifties. Even a decade later — the low point in Ted history — every town had its Teds. They sat in caffs talking past glories, playing pinball, and, still respected, impressing younger kids with tales from their formative years.

Hickinbothams of Eastwood — the top Teds' tailor for the area — have a shop in Ilkeston as well, now, run by Jack, the son of the founder. They supply a wide range of men's fashions but they have consistently held the Ted market: everything for the well dressed Ted: boppers, 'keeper' rings for the ears, bootstring ties, frilly shirts, bright socks, drapes and drainpipes.

A full-length tartan coat, with red velvet shawl-collar and cuffs hangs by the doorway, awaiting collection. Jack pointed to the coat: 'That is not a proper Teddy Boy drape. Originally, they weren't as flamboyant as they are today. They used to be mainly black with black velvet collars and a reasonable length. Still the basic tight bottomed trousers and quite a long jacket, but not ridiculously long. It should be box-cut, full-back; it should hang. Preferably, it should taper slightly towards the bottom, so it follows the line of the trousers.

'We always made finger-tip length jackets but very few coloured jackets. Now, we're making citrons, oranges, lemons, bright reds, and the tartan idea. And to outdo each other, they wear them to the floor sort of thing and they're dreaming up their own ideas. I made one a fortnight ago with ten buttons. His own idea, he wants to be different from everybody else, so he brings me a sketch.

'Late in the 1950s there was a craze for very light-blue jeans. I managed to get hold of some of them recently. Now, they've come in very useful.

'I can't understand why they ever wore them; I think they're shocking. They must be very uncomfortable to wear as well. I wonder sometimes, when they say they want twelve inch bottoms on their trousers, how the hell are they going to get into them. They get round it by having a little split up the side or having a zip on the inside seam.

'It's always kept going round here, the mining villages. It was the mining lads who caught on originally, rather than the young executives. I do very well with the lads from the Loughborough area, Draycott near Derby, and Nottingham.

'Now the young ones have started. I would think that, by and large, the young ones are the sons of the Original Teds. I would say, that with the modern Teds, if it faded out, they'd forget it. But the Original Teds, they'll stick with it.'

Gypsy caravans stand on the wasteland where the houses have been demolished. A back street near the centre of Sutton-in-Ashfield. At the end of the street, there is an old building; the sign outside glows dimly. It is the Golden Diamond Social Club.

A blast of 'Doo-Wop'. The lights are low and the music's high.

Ron Needham, a young, new-wave Ted organised the Saturday nights at the Diamond. He is President of Mansfield Rock And Roll Preservation Society. 'It's always been Teds round here; it never went out of fashion.'

The joint is packed. There are few Plastics present. Teds sit drinking in the dark, at rows of tables.

Original Ted, Stan 'Cap' Sutcliffe and his wife, Patricia, came over from Derby for the night. 'For me, it'll never go out. I've been Ted ever since there's been Teds. I've always worn the clothes. It's a lot to do with the older Teds, kept the thing going.'

Stan is forty-three. His grey hair in an immaculate short quiff, his dark-grey drapesuit fitting perfectly, he looks distinguished, as befits the winner of three Best Dressed Ted contests.

Patricia wears bobby socks. She has a wide white belt around her waist and a white flared, pleated skirt. Her shoes are white. When Chuck Berry saw them jiving in the aisle at his Stoke-on-Trent concert, he invited them to jive on stage.

Pete Mason stands at the bar. He is in his thirties but only became a Ted recently. 'When it was in its heyday, I never had any gear like this. The past couple of years, I went out and bought the gear at John Collier's of Mansfield. They don't make the proper stuff, though, with the full-back.

'Pop's alright but I prefer the old stuff. You can sit there; it's exciting; hear all the feet tapping. Some of the modern records... Too many sad records. You come out to enjoy yourself, have a good time. You have a good time.

'I went down Skegness last week to hear Showaddywaddy, sort of Pop version of Rock 'n' Roll. A good professional act but they can't generate the same excitement as Little Richard in his heyday. He jumped up and down on his piano: everyone's trying to emulate that. It's amazing really, a little place like this tucked away in a corner of England, because they like the music. It's known locally as one of the best clubs for miles. It doesn't look much from the outside but...

'I don't wear the gear for work. It'd look rather bad in a business office. I'm in a sales office, so it's got to be a pin-striped business suit. I've always said that one day I'm going to turn up in a bright pink suit with a black velvet collar, just to see what the reaction was. I suspect I'd be asked to go home and turn up in something more suitable.

'There's a mate of mine, Tony Tideswell, he wears the gear all the time — he's an Original Ted. His house is a shrine to Rock and Roll.'

Tony jived with Joy, his wife.

In 1955, forty-eight hours after he had finished his third film *Giant*, James Dean, method actor of *Rebel Without A Cause*, died aged 25. On the way to a motor race he smashed his aluminium Porsche Spyder on the Bakersfield Turnpike. He began the teenage 'Romantic Death' tradition which has not ceased since. A year after his death, he was still receiving 6,000 fan letters a month — some smeared with blood and tears. His smashed up wreck was publicly exhibited for money.

Tony and Joy Tideswell live in a flat above some shops, on a housing estate on the outskirts of Mansfield. In the living room, a giant poster of James Dean dominates the wall opposite the window. At the end of the room, a Seeburg Selectamatic 200 juke glows like the back end of Captain Video's space-shuttle. It pumps out Johnnie Burnette, *Dreamin'*.

Tony's mate, Bob called in his purple Vauxhall Cresta. He wore black winkle-pickers with white tops. 'I just hit lucky. I went into a really old shop. They bring 'em out, dust all over 'em, and you've got a pair of genuine two-tone winks.'

He sported a dark Donegal tweed sports coat which had a gold lamé thread running through the weave. The lamé weave sports coat, an Australian invention, made its first British appearance in 1955, in a London fashion show *The New Glitter Look For Men*, held to celebrate the tenth anniversary of the introduction of Lurex thread.

Tony has James Dean tattooed on his left arm. 'I had 'em done at Ron's in

Sutton, just up from the Diamond. Some don't like tattoos, but a lot have 'em done. I don't know why we have tattoos... It's summat to do, innit? Shows you up, don't it? I've had 'em done a couple of years. Ron draws the outline for 'em like. (He raises his other sleeve.) He drawn that one, in all: it's a Ted Girl with a pencil-skirt.'

'It's like this, isn't it? Styles can alter and Mams and Dads'll let their kids follow any style they like until it comes back to the Fifties. As soon as they want a drape, they think back to when they can remember — the razors and flick-knife days — and then it's time to stop with them. They don't want 'em to follow that style. It's alright with *Soul* and being *Mod* and all, that crack. It don't really bring trouble into their minds, *Soul Music*. But as soon as you say Teddy Boys, Fifties, it clicks: violence.'

BOB: 'Round here, there was that many little towns near each other, if you ever went out for a night in another town, you got beat up, or run out of the place, or caught the next bus out of town. You didn't wear flash drapes. Gush Wood, he was the first one round here to have a flash drape. He died; fell off a window-sill, doing some building work at Parkhurst. If you wore a flash drape, you were the target for the night. Each town had its own colour drape. Mansfield, Cross's Gang, they wore black drapes. Sutton was bottle-green with a black collar and Normanton: midnight blue.'

(There was a similar distinction in London, in the Fifties. There it went on colour of socks.)

TONY: 'Aye, and Shirebrook, everybody had their own little clique. They knew where you were from. Dances I used to go to, near where me Mam lives now. Only down the bottom of the street, there used to be a church hall, St. Lawrence's. Well, there was a gang came over from Sutton one night. And it blocked off the traffic with the fight outside. They were next to a gardening allotment. They were grabbing hold and ripping these fence poles off — rough cut fences, like. They were fighting with them. Fighting with old buckets with the bottoms out, from round the rhubarb, off the gardens.

'There were a well-known crowd from Sutton gang and there were a well-known crowd from Mansfield: Cross's gang. They were a lot of brothers and they used to have a lot of followers. They used to have a caff where they hung out: the Adriatic, across the road from the Electricity Board offices, a leather shop now. If they didn't want anybody in that caff, they'd push 'em out. Like, either give them a good hiding or look round a few times and you'd go your sen, know what I mean?

'It were like that, gangster sort of a caff. This lot went in there and if anyone went in, they didn't know or didn't like, stick the boot in.

'This were when I was a youngster; they were a bit older than me. They all wore the gear. That's how this caff used to be. It got shut in the end, by the police.'

BOB: 'See, there's not so much trouble now because you don't want to lose a place. When I first met Tony, there used to be a place down Jacksdale. We used to go down there every Saturday night. They got shut down 'cos of trouble...'

TONY: '...Toilets ripped out, glasses, fighting and that. There were groups from Birmingham, Southend, London. It used to be packed with Teds and Ted Girls. Used to come from all over. It were an old cinema converted into a dancehall.'

Tony and Joy keep an extensive photo album which covers twenty years of Tony's life as a Ted: 'This were the first Mark II Zodiac I had — 1960 that one.'

JOY: 'We got a Yank but we had some trouble with it.'

TONY: 'Aye, it's at me Mam's house, other side of Mansfield. I had to get it off the road. I had to get it off the road 'cos the police done me for riding it in a dangerous condition.

'He rammed me, a Mark II Cortina, wrote that off. But they got a good old chassis on the Yanks — a '60 Gull-wing Impala. Got a Zodiac, in all.

'It all revolves round these Fifties films, doesn't it? With all the Rock and Roll stars having these big flashy cars, with wings on. That's what it's all about really. I mean, you try and relive them days. That's what it's about with us.

'There's lads even dress like James Dean; that's the denim jackets and jeans, rough looking in a tidy sort of a way, and the girls try and dress like Marilyn Monroe. Rebellious, James Dean; that's what it's all about.

'These are some of my old pictures, when I used to have motorbikes as well. I used to do a bit of motorbike racing, in all, me and my mate. That's us on our first outfit. There's a couple of other of our mates. He got killed, the Isle of Man TT, Denis, came from Doncaster.

'That's a lad who lives in Mansfield now. He's still alive but they packed it in when Denis got killed. You know, motorbikes, Rock and Roll records, Yanky cars, everything is all mingled in with the lads.

'That was at Skegness, when the Mods and Rockers were in. I was a Rocker then, kicking scooters about.

'That's the Ship Inn, that is. I'd had a bit too much beer and got my ratter on backways. All the lads have got decent tidy haircuts. All wore a lot of ratters. I've still got a red and black one and a blue and black one — corduroy — you can still buy them from the Army Stores, with a buckle on the back. 'Cheesecutter', we used to call 'em.

'In the old days, a lot of the lads used to have razor blades sewn into the seam. If you had any trouble, if you hit somebody, you could cut 'em really bad. If you hit somebody across the face with a ratter with a razor blade sewn into the peak.

'And the back of the lapels. If anybody got hold of you, to stick the head on you, they'd cut their hands open. Or fish-hooks, right early.

'This is the Blue Boy at Chaddesden. That's where we're going tonight. You'll have a good time because there's some right dedicated lads there, I'll tell you. It'll be a right good night because they're all genuine lads. There's no bums there. You'll enjoy it — a good round up to the weekend for you.

'You get a load of old ones there for the night out. We've been down in London and there's a lot of kids. Very young; you don't see that up here, not as young as fourteen.'

JOY: 'When we went to Alexandra Palace...'

TONY: '...Round here, they're in the house at ten o'clock. They let them do as they like down there, the Mams and Dads.'

The Blue Boy pub is on a housing estate, at Chaddesden, just outside Derby. 'Rockhouse 58' holds a disco in the back room. On the small stage, behind D.J. Shakin' Pete, stands a dummy Teddy Boy, a cross between Alvin Stardust and Guy Fawkes. The Derby Teds take the dummy with them when they go to carnivals.

There is a hand-painted poster on the wall, depicting an air crash:

THEY WILL ALWAYS BE REMEMBERED
1959: BUDDY HOLLY, BIG BOPPER, RITCHIE VALENS
THEIR MUSIC LIVES ON
FOREVER ROCKIN'

Dennis Knight came over from Sutton Coldfield with his dancing dolls, little Teddy Boy and Girl puppets which his mum made for him. He bopped; his dolls moved with the music. Mesmerised, 'I do it all the time 'cos I like it.'

Big John, the bouncer, lumbered over. 'Rockhouse 58 is one of the best discos what there is in the Country. They all know me. I believe in nothing else but this music. (*Teen Angel* is playing.) I'm well-known in straight gear: I'm well-known as a Ted. I can go anywhere in this town and, any Teds, I can be shouted for.'

Sheila, who lives on the estate, called in. 'We were all Teds in them days. It was a lot different from what it is now. They do quite a lot of bopping here, where we used to do jiving.

'It's the music, some of the music. It's got meanings in the words, as well. I liked the stars in them days. Eddie Cochran, he died when I was nineteen. Elvis, I love his music. Gene Vincent, he's dead too now.

'I used to wear the pencil skirts. I used to have my hair short, in waves. They didn't wear tights at all then. I used to wear ankle socks until I was twenty-one. I didn't wear stockings at all, just the ankle socks.'

In the lounge bar, Smoothies and Teds mingle. A man sits with his wife and their French student guest. He has just won the raffle.

WIFE: 'Well, we were Teds...'

HUSBAND: '...She was a Ted; I was never a Ted.'

WIFE: 'I like the finger-tip drapes and the girls...'

HUSBAND: 'I like the music...'

WIFE: 'The skirts, with the underskirts, particularly from Nottingham. It's the city for lace. You had layers and layers of underskirts; it was lovely. It's our first night up here, although we do go regular jiving, don't we?'

HUSBAND: 'We like jiving.'

WIFE: 'We like the drapes but we realise we're past it, don't we?'

HUSBAND: 'I think it's really silly to see older people in the drapes of the Fifties. You tend to grow up a bit. A lot of the young lads that are coming up: great; it's a great style.'

Pat, from the Red Planet Disco was visiting the Blue Boy; she came over.

PAT: 'There's a lot of folks never left it.'

WIFE: 'We never left it.'

HUSBAND: 'It was the kind of people who wore thick-soled shoes...'

WIFE: '...Liked the music.'

FRENCH STUDENT: 'Oui, c'est fantastique.'

WIFE: 'He's won three records tonight: Fats Domino and Elvis. I like Elvis.'

PAT: 'I think he was too commercialised. You see, I went right off Elvis when he dyed his hair. His hair, that was not his natural colour.'

HUSBAND: 'Who's hair?'

PAT: 'Elvis's. It was ginger-blonde by nature. He dyed it to get it black. I saw this picture of him with it blonde. That was it; no more, Elvis, for me, had to go.'

HUSBAND: 'I don't worship him: I worship the music.'

In the back room, winding down, Shakin' Pete closed the show: 'Thank you very much. This is what it's all about.' Then followed Three Stars, a requiem for Buddy, Ritchie, and the Big Bopper, talking words and funeral guitar. They are missed. Three Stars shows the promise of youth cut short. Death gives absurdity meaning.

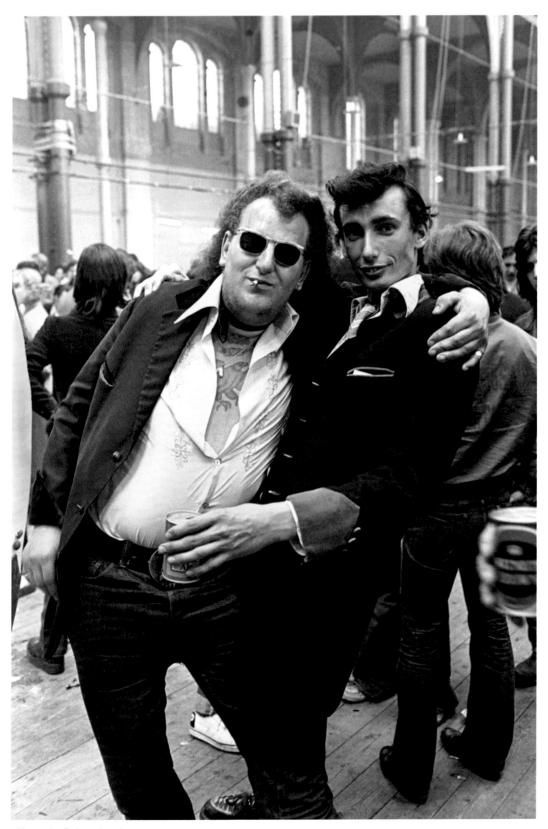

Alexandra Palace, London

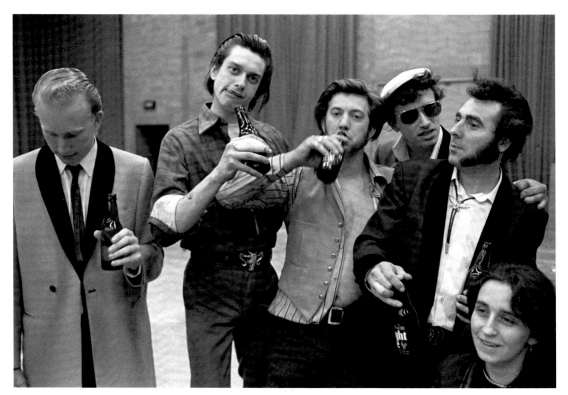

Pickett's Lock, Edmonton

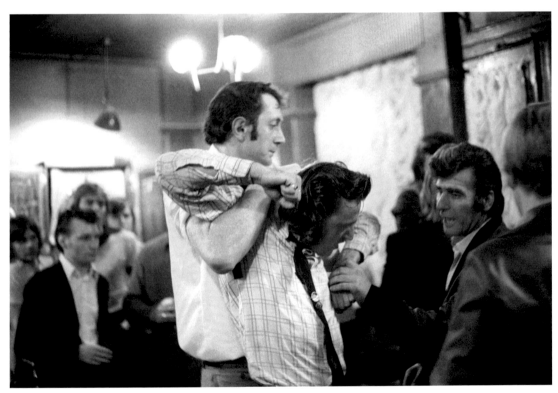

The Winchester, Elephant & Castle, London

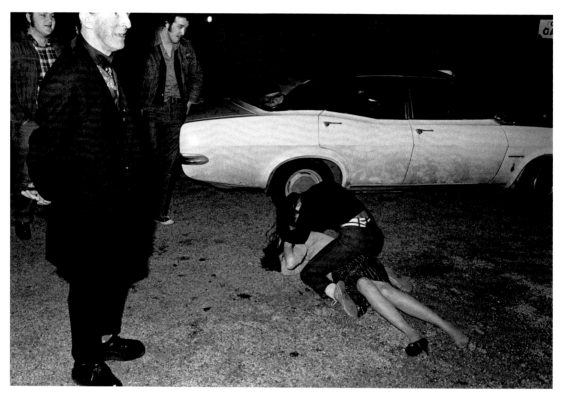

The car-park of The White Hart, Willesden, London

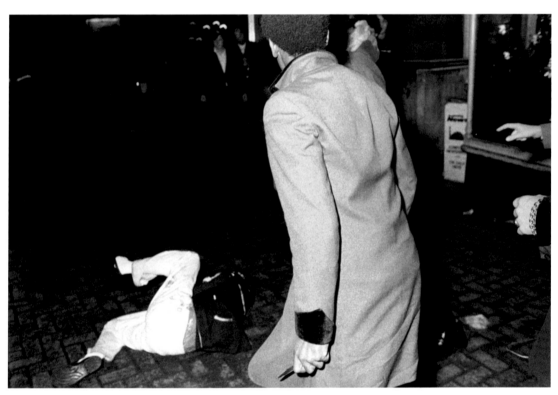

Outside The George, Hammersmith, London

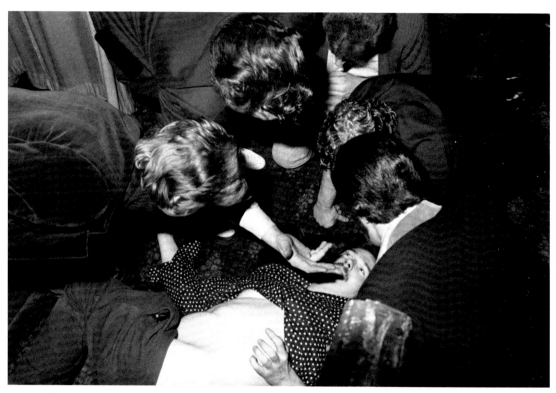

Lyceum Ballroom, London

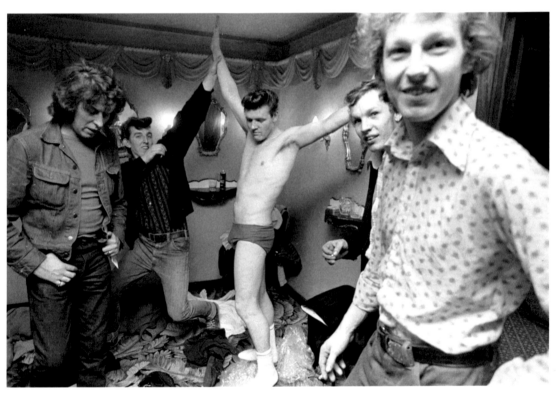

Pete Presley in the dressing-room, Portsmouth Locarno

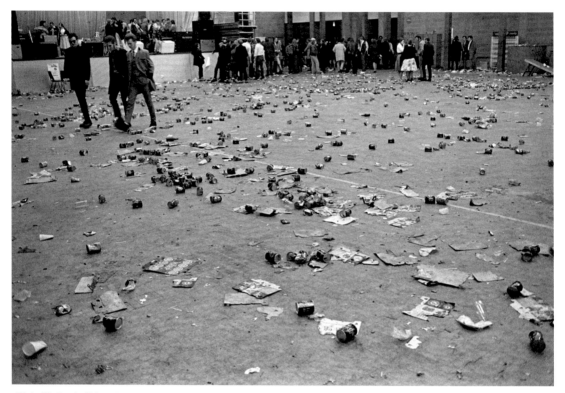

Pickett's Lock, Edmonton

Be There Or Be Square

ROCK 'N' ROLL
MARKET TAVERN
SUNDAY LUNCH

Bradford. Down in the cellar bar, Paddy Womersley, Tony Vallence, Attila, and Eddie Cockrot sat drinking and smoking Woodbines. They passed a flick-knife around admiringly. At the bar, the Captain stood at his turntables, looking mean in studded leather. D.J. Steve 'Captain Kirby' claimed that he was due to be weighed off for pulling a flick-knife on a copper.

Bradford Boys strive hard to be Fifties teenage desperados. Paddy has a scar all the way down the left hand side of his face. He is twenty years old. 'Two years ago, this Jamaican slashed me with a razor in a pub called The County. Right hole, the sort of boozer we'd never get barred from.'

'He got fifteen-hundred quid compensation, should see the record collection he's got now.'

'Sometimes, we're violent like they used to be. But we don't look for trouble. I think that Teds sort of walk into it. You know, we get looks; the police don't like us much.

'I've been picked up on t' Moor, me an' 'im. There was a fight at a bus-stop and just 'cos there were two Teddy Boys standing there, they picked us up, saying we were fighting each other. And we both got fined.'

Paddy has had a large number of tattoos done over the years. 'I were twelve years old when I got my first tattoo. I like 'em. Yeah, I enjoy being tattooed. When the needle's sticking in, it hurts that much, it's a thrill. It really hurts when it's going at your arm; I nearly pass out. But it's not just Teddy Boys who have tattoos, is it? I've seen bloody Smoovies with more tattoos than I've ever bloody seen. We're different.'

The organiser of the Bradford Teds is an Indian mechanic, Pargat Singh. He edits 'Yorkshire Rock 'n' Roll Scene' — the local Teds' magazine. He used to play for Bradford Rock 'n' Roll band, Reddy Teddy. He casts brass lion's head belt buckles, using a doorknocker as a model. Most of the Bradford boys wear the Lion's Head.

Pargat drove the gang down to London for the Rock 'n' Roll march. James Dean's *Rebel Without A Cause* was showing in Leicester Square. 'So we stood under the poster and got our photos took with Jimmy Dean, didn't we?'

The only woman in the place jived with her boyfriend. Paddy's mob got some aggro from the older boys. 'There's Brian who comes in here, he's about 29; he's second generation. I don't know why it is, but he don't like us. We had a bit of bother with them last Wednesday. When we go anywhere and start bopping, they say "Wankers" and all this sort of thing. But none of them can bop, can they? They're all bloody rubbish.'

'They call us Plastics. Plastic? Plastic Ted, actually, is a Smoovie in disguise. You can see 'em in town with wedges on and Oxford bags, a drape jacket and a big flared-collar shirt. In London, you see a lot of Plastic Teddy Boys, Manchester: a corduroy jacket, with a big slit up the back and a wide velvet collar — that's what I call a Plastic Ted.'

Who's Opened their Sandwiches?

The North-East, like the East Midlands, is an area where the Teds kept going. The Geordie Teds came into the game later than their counterparts in the South. But they stuck with it, less self-conscious, dressing for a natural style, rather than to the dictates of Ted conformity.

Rockin' Jim, an Original, founded the North-East Rock and Roll Society. Their big night is Friday at the Five Wands Mill pub downtown Gateshead.

The Geordies don't discriminate between Smoothies and Teds; they just dress up for the night out. The relaxed attitude towards clothes extends to the music as well. Unlike Teds in other areas, they do not adhere strictly to American Rock 'n' Roll.

The D.J. makes an announcement: 'We've got two sandwiches left, if anyone wants one. One of them's cheese and onion; the other one's cheese.'

The Pink Panther stood at the bar. The points of his shirt collar had chromium-plated clip-on tips. 'Mate got 'em for me in Chicago.

'Ah been a Ted ahboot seven years. Before Ah wor a ted, Ah wor a Rocker — that died so I went doon to the drapes, wore 'em ever since. The music comes first with me, like.

'You walk doon the street with the drapes on, folks say, 'Hey, that's Rock 'n' Roll'. That's why Ah wear the drape, like. Ah got this drape ahboot five years ago, then it cost forty-five poond. Noo, it'd cost close on eighty. You see the length: finger-tip. This is the shortest one Ah've got.'

Mick Rankin, they call him the Pink Panther because of his penchant for dusty-pink drapes.

New Boldon is a colliery town that lies off the main Newcastle-Sunderland dual carriageway. Across the road from the British Legion, is a shop. Above the window, TAT-2-R-TIST is written in oriental script.

Tuesday night is Teds' night at the Legion. In the concert hall, people of all styles and ages gather to relive the years.

Paul Campbell, the Flying Scotsman — he wears tartan drapes — came over from Hebburn-on-Tyne. 'Used to wear the ice-blue jeans. In the old days, there wasn't the money about. We couldn't afford drapes; tailoring's expensive. Paid hundred and six quid for this coat and pants. Five years ago, in Hebburn, there was a couple of hundred Teds, choc-a-bloc. It's dropped off a bit.'

They auctioned off some records. *April Strings* by Cliff Richard went to somebody by the door. The D.J. stood beneath a portrait of the Queen and the slogan:

ROCK AND ROLL IS HERE TO STAY

Long in the quiff, the Flying Scotsman jived skilfully despite his lumberjack build. His hair followed a perfect algebraic equation.

The Pink Panther looked blue that night.

Sat in the corner was Steve Ball of Boldon, Britain's only Hippy-Skinhead-Ted. Wide skinhead trousers at half-mast, royal blue drape. His fair hair very long. 'Rock and Roll, you cannot beat. But, the modern age, nowadays, Skinhead's always in. But up here, everyone's always friendly.'

His mates were less equivocal. 'The Teds are a load of fucking shit,' said Gordon, 'we only come here for the booze.'

'They're crap,' said Hutch, 'I only come here for the fanny.'

Clive Jerrams is a steel-erector from Sunderland, Maltese Crosses dangled from his lobes. He wore black skin-tight jeans and a grey drape. A giant red swastika formed the buckle of his belt.

'Swastikas: I've no idea. I made this belt myself. I used to ride with a bike gang from Sunderland, till I turned Ted: Satan's Slaves.'

An old man jived with his wife.

It being the British Legion, at the end of the evening, everyone rose for the National Anthem. Then outside, on the cold street of the town, the man with the hot dog tricycle did good business.

Go Down Southend Bank Holiday Monday, Any Bank Holiday Really. Ted's Day, that is.

It's Easter time. At the Queen's Hotel, which looks like the motel in Psycho, The Flying Saucers do the lunchtime session. In the car park, a pink and black Ford Consul vies for attention with the Zephyrs and Zodies, and a grey Chevrolet Malibu. Pete Barnes swings in, in his new acquisition, an immaculate twenty-one year old, leaf-green Humber Hawk. Then it is time for the March on the Town, to the Kursaal Amusement Park. A Ted and his wife, in matching mustard drapes, stroll. A copper drives by in his van. 'Hey up, you fucking old filthy cunt, you.'

Down the Prom they walk; some ride in cars.

The Vauxhall Cresta brakes sharply. An old age pensioner in his Mini also brakes. The Chevy Malibu goes straight into the boot of the Mini. The driver is Ted from Colchester; Brenda and Kim sit in the back.

On hearing the crunch, Battersea Dave gives the 'Teddy Boy Roar' and runs over. He shouts at the old age pensioner: 'Move it!'

His mates come over: Fuckin' Hell, look move it. Move it or we move it.'

Bullying the old man, whose wife sits in tears, Battersea says. 'It were your fault, mate, your fault.'

A lady from a cafe comes and rescues the old couple. A Teddy Girl persuades the boys to leave: 'We've all enjoyed ourselves today and that's the end of it.'

The Malibu roars off.

People along the Promenade stare at the Teds. Across the Thames Estuary, a chimney burns at the Isle of Grain Oil Refinery. The Teds sing 'Oh, we do like to be beside the seaside.'

Battersea Dave shouts abuse at a group of blacks sitting on the beach. The blacks laugh.

A street trader sells his jewelry: 'There's the bracelet, one. There's the locket on the top, number two, double-sided — you open it up and you get a picture of your boyfriend one side and your husband the other. Close it up and hope that it's the only time they meet, else there'll be trouble. The Wedgewood cameo goes on top, number three. And last, but by no means least, there's that lightweight American fish. There's a tenner's worth of commercial value. If anyone wants them...

The Chevy Malibu heads back up the Prom. This time a copper is driving.

ONE-TWO-THREE-FOUR, Let's hear the Teddy Boy Roar: OOORRRRRRRROOORRRR.

They make it to the fairground. Teds surround the dodgems. There has been some bother.

ICY: 'They took someone inside a little place round here. They were kicking fuck out of him. They were surrounding the jailhouse; we got some coppers' hats and stuff.

'There was three-hundred-million-billion Teds, like, and one fucking copper. They got hold of the geezer; the copper wouldn't let him go. It was pretty good, like. Something, you know, that all adds up to a day's entertainment. Couple of coppers got a kicking on the floor.

'"No, you cunt, I'll take you anyday." So then he went BANG, BANG, BANG. The coppers tried to nick a Ted. It took them twenty minutes to take him from there to there, like. And they lost five hats. There was five of them got done, like.'

Young Plastics crowd round the hut marked 'Laff like Helen 'B' Merry'. A poor quality house of horrors; people keep bumping into each other in the dark.

Teds make the man in the kiosk of the 'Speedway' miniature motorbike ride play Rock 'n' Roll. 'C'mon all you Teds, clap your fuckin' hands.' Some bop on the tarmac. One Ted belts round on a bike; he wears a small papier-mâché 'P.C. 49' helmet. Some of the girls wear 'Kiss Me Quick: Squeeze Me Slow' cowboy hats.

Slowly, they straggle back to the Queen's for the evening session.

The Flying Saucers played. Eddie, from Brentwood, sang a duet with Art from Woolwich.

ONE-TWO-THREE-FOUR, LET'S HEAR THE TEDDY BOY ROAR!
OOORRRROOORRRRR

The session ended with the Teds carrying the Saucers round the room on their shoulders. A ginger-haired Ted thumped his identical twin brother in the mouth. They both wore black drapes with red velvet half-collars.

Pete Barnes prepared to leave in his new Hawk. 'Teds' Day, innit? Stick together. Half this lot tonight, if there was any bother, they'd be over.'

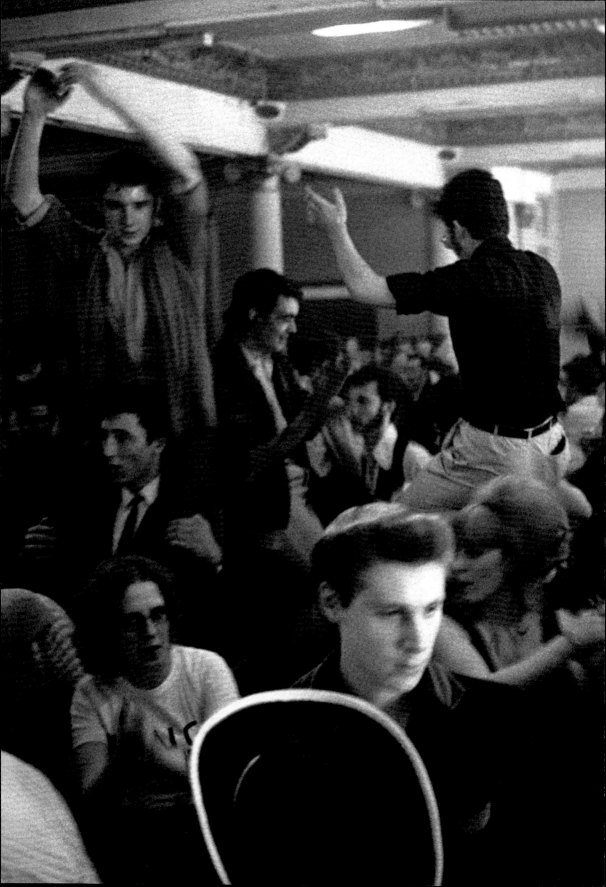

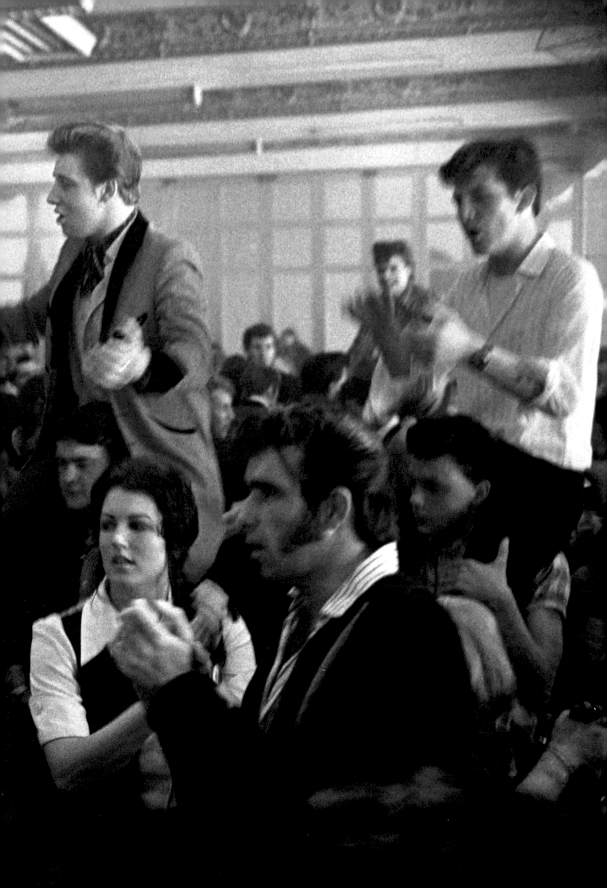

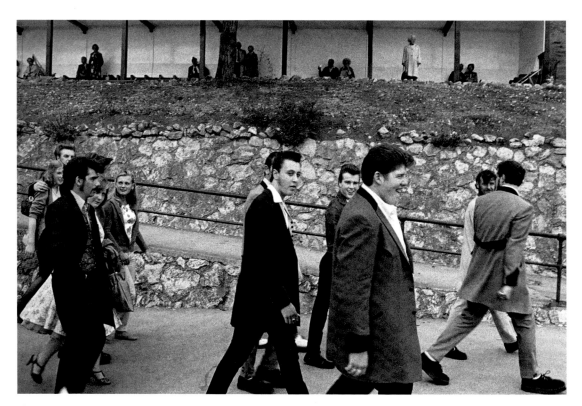

Southend Promenade

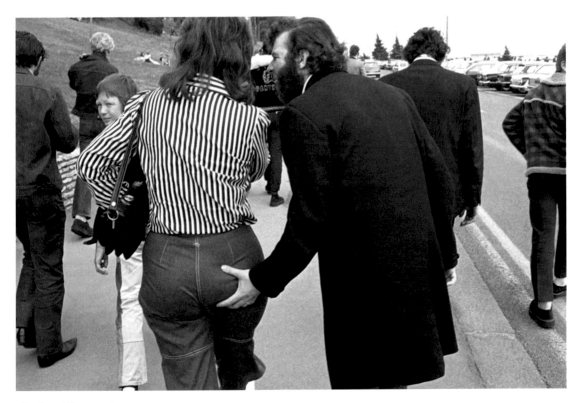

Southend Promenade

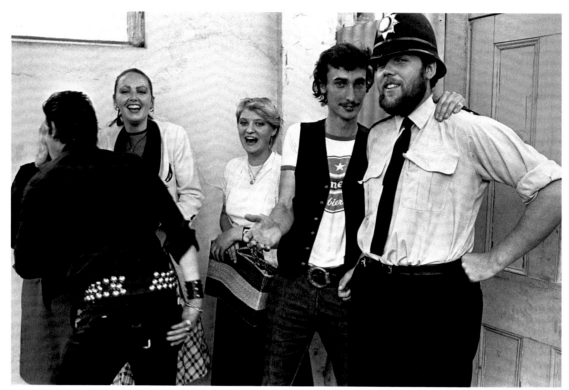

Kursaal Fairground, Southend

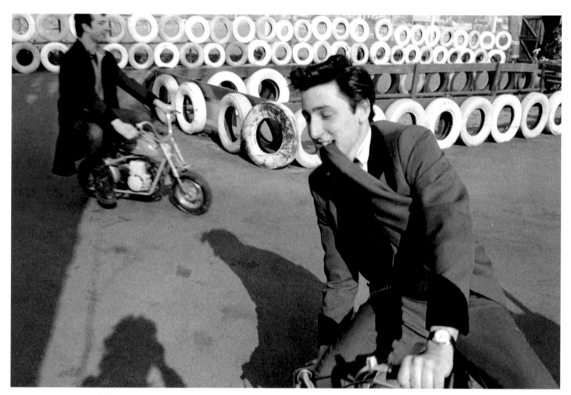

Kursaal Fairground, Southend

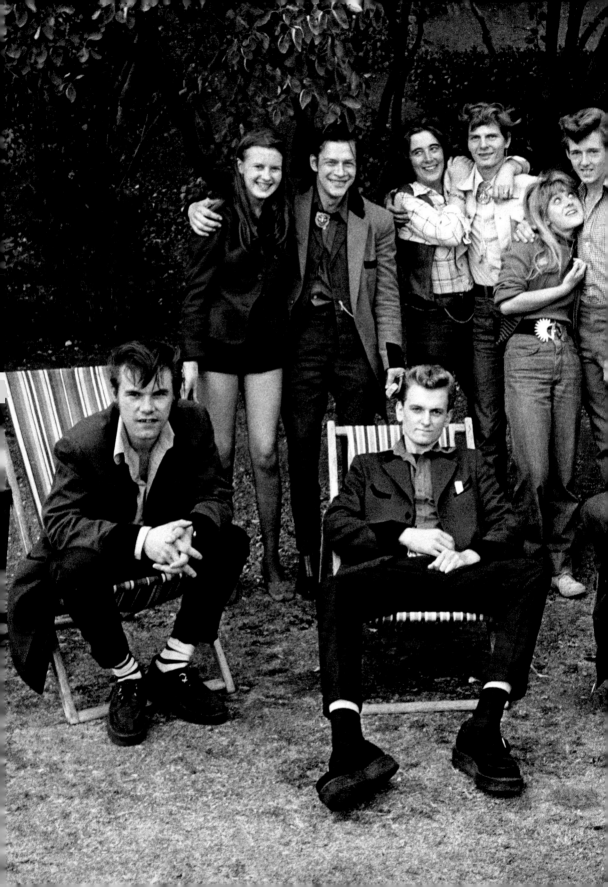

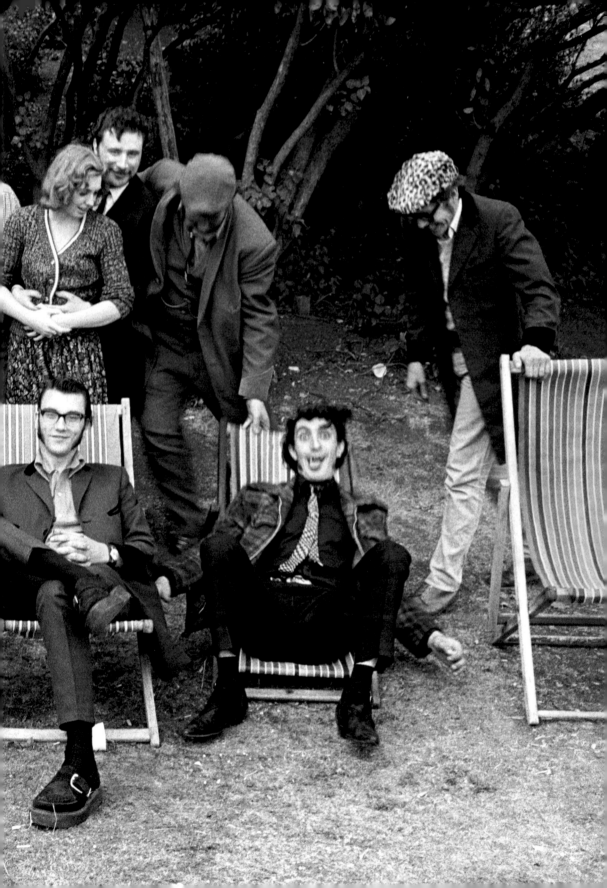

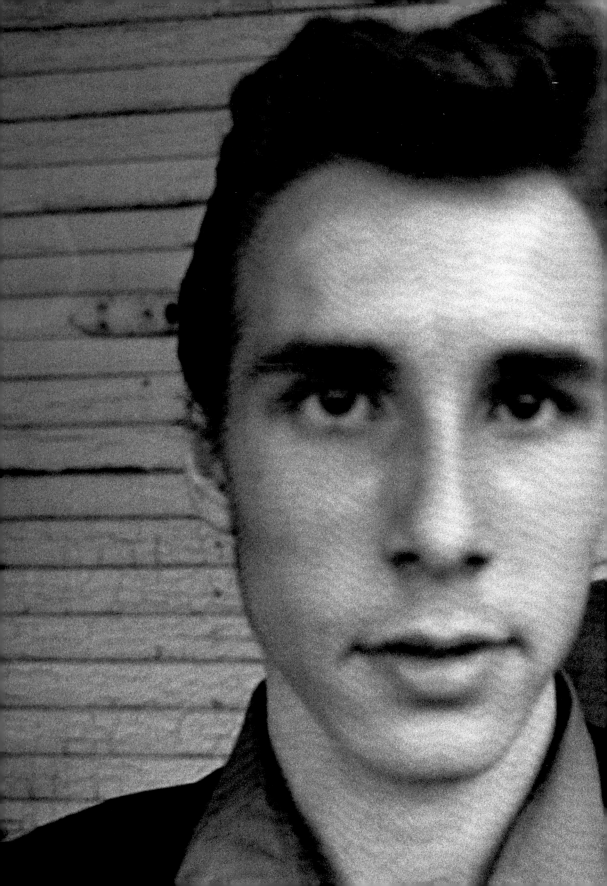

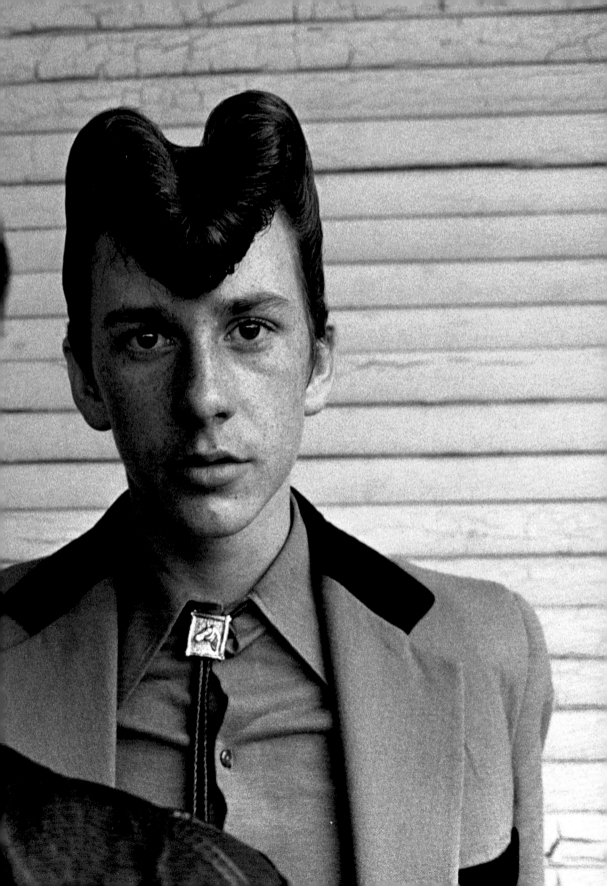

Deja Vu

Augustust Bank Holiday back at the Queens, Southend, Eddie, from Brentwood sang a duet with Art, from Woolwich.

ONE-TWO-THREE-FOUR, LET'S HEAR THE TEDDY BOY ROAR

ONE-TWO-THREE-FOUR-FIVE, ROCK 'N' ROLL IS

STILL ALIVE

The Flying Saucers ended the lunchtime session with a bout of shoulder-riding. A pillar-box-red drape, studded leather belt, gladiator gyrated. Girls practised jiving in the toilet.

I'M COMING HOME IN FORTY DAYS.

A coach driver wore a chromium-plated badge: DRIVER, in neo-Gothic. A man wore a jacket: ERIE COUNTY BUFFALO AMERICAN LEGION.

The shoulder riding ended when the Saucers had been carried round the room in triumph. It was time for the march on the town, to the Kursaal Amusement Park.

On the way, a big Ted in a blue drape beat shit out of a little Ted in a black drape.

'Bastard! Bastard! I'll do you.'

'Leave it off.'

'Bastard.'

'I come from London an' all, Mate,' the little Ted pleaded to no avail.

'For fuck's sake, leave it off.'

The little Ted was bruised; he looked on the point of crying.

'Ol' Crazy Cavan got cut up by the Road Rats, down the Adam and Eve, won't be playing for a long time yet, I bet.'

OOORRRROOORRRROOORRRRROR

The Teds were looking for trouble. A Ted in an emerald-green drape shepherded them up on to the half-burnt-out pier. An emerald-green hairspray aerosol protruded from his pocket. The police followed.

Further along the Prom, the big Ted had another go at the little Ted. His friend shouted across to him. 'C'mon, hurry up, Terry, my Missus is waiting.'

On the fairground, Plastics fooled around outside the Tip-The-Girl-Out-Of-Bed stall. The young girl lay in bed, eating a toffee apple. Throw the balls; if you hit the target, the girl falls out of bed.

Icy was dressed in leather; he had turned grease.

There were quite a few cuts, bruises, and black eyes on display. Battersea Dave had been done over by Smoothies at his local. Ron Staples had been badly injured; The Road Rats had kicked him in the face when they did over Crazy Cavan.

Peter Barnes hit town in the late afternoon. 'It's gone off. Easter's best: start of the Season. By the end of August, end of the Season, it's started to drop off a bit. Folks getting fed up.'

There was the all pervasive smell of hamburgers, onions, and fish and chips. At the top end of the fair, Teds surrounded the 'Speedway' ride. Brian had his third go on the miniature motor bike.

CUT ACROSS, SHORTY

Brian's purple creepers bounced off the Tarmac as he cut it on the bend. He nearly fell off the bike. Cut across. He wore pink and black hooped socks. A green plastic comb stuck out of the back pocket of his black drainpipes.

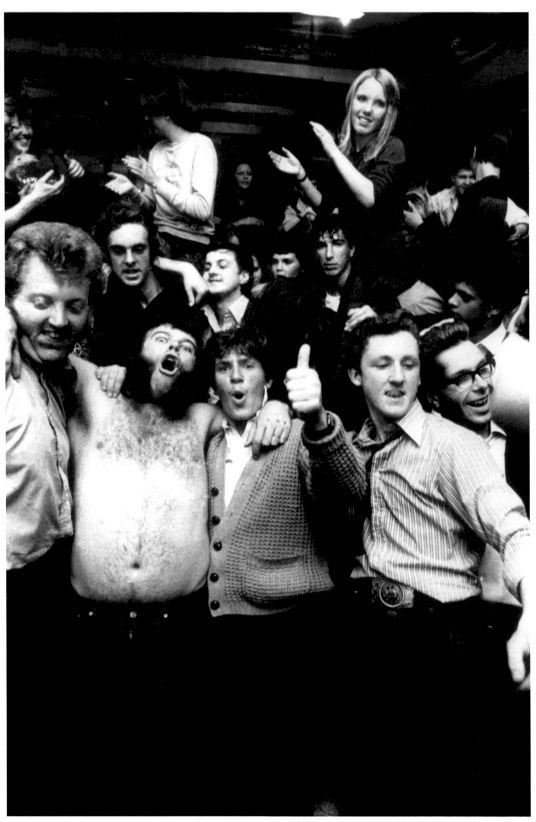

The Queens Hotel, Southend

He was naked to the waist. There was a peacock tattooed on his right arm. As he put-putted up the straight, a not very realistic tattoo of Elvis was revealed to the crowd. Above it, the slogan:

DON'T FOLLOW ME
I'M LOST
TO

Late that night, on the last train from Southend to London, a girl who fancied Ron Staples talked about him. A deaf-mute Ted, whose name we never knew, tried to chat her up. She could not understand him. He became very agitated. He pulled the communication cord. The train screamed to a halt, somewhere East of Barking.

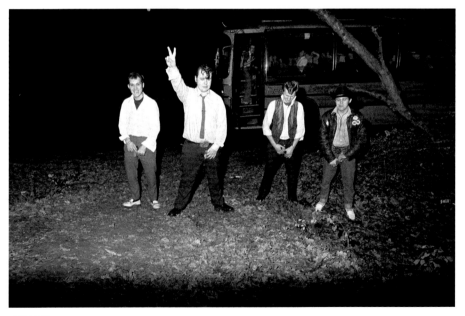

Farewell

1. The Times, 25 March 1954
2. The Times, 4 December 1952
3. The Times, 10 January 1953
4. The Times, 19 January 1953
5. The Times, 30 January 1953
6. The Times, 17 September 1956
7. The Times, 14 September 1956
8. The Daily Mirror, 27 September 1956
9. The Daily Mirror, 27 September 1956
10. *Summertime Blues* Eddie Cochran reproduced by kind permission of Campbell Connelly & Co Ltd.
11. *I Fought The Law* reproduced by kind permission of Acuff-Rose Music Limited, (Chappell & Co Ltd)